Seurat at Gravelines: The Last Landscapes

Seurat at Gravelines

The Last Landscapes

Ellen Wardwell Lee

With an essay by Jonathan Crary
and biography by William M. Butler

Indianapolis Museum of Art
in cooperation with
Indiana University Press

Seurat at Gravelines: The Last Landscapes
Indianapolis Museum of Art
October 14 to November 25, 1990

This exhibition was organized by the Indianapolis Museum
of Art with the generous support of Robert H. Mohlman,
Marsh Supermarkets, Inc. of Indianapolis, and the
National Endowment for the Arts. Additional support
has been provided by the Indiana Arts Commission
and the City of Indianapolis, with an indemnity from the
Federal Council on the Arts and the Humanities.

For Steve — a wedding present.

Library of Congress Catalog Card Number: 90-083128
ISBN 0-936260-55-6 (soft cover)
 0-936260-56-4 (hard cover)

Published by the Indianapolis Museum of Art, 1200 West 38th
Street, Indianapolis, Indiana 46208; telephone (317) 923-1331.
Distributed by Indiana University Press, Bloomington, Indiana
47405; telephone (812) 855-6804.

Editor: Debra Edelstein, Boston, Massachusetts
Designer: Nathan Garland, New Haven, Connecticut
Production Coordinator: Della K. Pacheco, Indianapolis, Indiana
Compositor: Southern New England Typographic Service, Inc.
Printer: Meridian Printing, East Greenwich, Rhode Island

On the cover:
Georges Seurat, *The Channel at Gravelines, Evening,* 1890
Oil on canvas, 25 ¾ x 32 ¼ inches (65.4 x 81.9 cm)
Collection, The Museum of Modern Art, New York
Gift of Mr. and Mrs. William A. M. Burden
Photograph © 1990 The Museum of Modern Art, New York

Contents

Lenders to the Exhibition

Berggruen Collection

André Bromberg, Paris

Indianapolis Museum of Art

The Museum of Modern Art, New York

Private Collection, Paris

Private Collection, Tokyo

Private Collection, USA

Rijksmuseum Kröller-Müller, Otterlo, The Netherlands

Solomon R. Guggenheim Museum, New York

Victoria and Albert Museum, London

Foreword

What do you call an exhibition with only four paintings? It can't be a "blockbuster," can it? Blockbusters, as we all know, contain hundreds of objects and draw thousands of people all jostling to catch a glimpse of them. Success is measured by the length of the queues to get in. Is this really the way to assess the quality of what a museum offers the public? Can the vitality of our cultural life really be gauged by the "gate"? Increasingly, people are recognizing that there has to be a better way.

If, as many thoughtful people believe, the blockbuster is the antithesis of everything an art museum should stand for, then perhaps what is wanted is a kind of exhibition that is the antithesis of the blockbuster. Such an exhibition would invite visitors to focus their attention on a small number of significant objects and would incorporate a number of interpretive strategies intended to promote understanding and enjoyment. Instead of overwhelming us with all the masterpieces of an age or an artist's entire oeuvre, and sending us back to the streets reeling with fatigue and numbed by excess (though convinced that whatever it was we experienced must have been worthwhile, since so many other people were dragging through it as well), the anti-blockbuster would challenge us to rise to the occasion and bring our senses to bear on just a few well-chosen things.

Consider the story of a flower grower in sixteenth-century Japan whose garden of rare morning glories was the finest in the realm. Informed that the Taiko wished to see his famous garden, the grower invited that powerful man to morning tea. When the Taiko arrived he found that all the flowers had been cut down and the ground leveled and covered with pebbles. His fury abated, however, when he was ushered into the tea house and saw in the *tokanoma* niche an ancient Chinese bronze vessel displaying a single, perfect blossom. The garden owner knew that contemplation of a single superb flower would bring greater joy to a person of sensitivity than distracted gazing on a whole field of blossoms. His dramatic gesture was the highest compliment he could offer the Taiko.

This exhibition of the last four landscape paintings and related studies by Georges Seurat would seem to be the prototypical anti-blockbuster. Like the Japanese gardener's perfect blossom, it presents a narrowed field of focus that will yield unexpected rewards to the attentive viewer. This small exhibition challenges us to contemplate the exquisite canvases nurtured by a master of early modern art.

Seen in the context of the finest examples from the museum's Holliday Collection of Neo-Impressionist paintings, this quartet of superb canvases takes on added resonance. This exhibition fittingly inaugurates the Mohlman Gallery of Neo-Impressionist painting in the museum's new Mary F. Hulman Pavilion.

Ellen Lee, who has organized this exhibition of Seurat's Gravelines paintings, also wrote the catalogue for the Neo-Impressionist paintings from the Holliday Collection. To have brought the Seurat exhibition and catalogue into being while serving as senior curator of the IMA and supervising the planning and reinstallation of the painting and sculpture galleries is an extraordinary accomplishment, for which she deserves complete credit. Ellen joins me in thanking all those, both outside and within the museum, who have helped shape this exhibition. Our particular thanks go to the lenders and to Dr. Jonathan Crary, whose perceptive catalogue essay helps situate Seurat's Gravelines paintings in the broader context of the art and thought of the 1890s.

Bret Waller
Director

Acknowledgments

From the very beginning, the idea of reuniting the Gravelines paintings inspired enthusiasm and a distinct spirit of cooperation. The thought of assembling Georges Seurat's exquisite last landscapes for the first time in one hundred years had captivating appeal, but of course its realization was totally dependent upon the generosity of the museums and private collector now responsible for these works. Since we had resolved that the exhibition should take place only if all four canvases were present, each lender's commitment was crucial. My warm thanks go to Dr. R. W. D. Oxenaar, director of the Rijksmuseum Kröller-Müller, for his willingness to interrupt the seamless beauty of the five Seurat paintings that gives Otterlo one of the most magnificent walls in the museum world. Dr. Kirk Varnedoe, director of the department of painting and sculpture at The Museum of Modern Art, gave the project strategic support and endorsement by agreeing to lend his museum's Gravelines canvas to the exhibition. One of the most enjoyable aspects of organizing the exhibition was the opportunity to become acquainted with Mr. Heinz Berggruen. His patience, his good humor, and his efforts on behalf of the project through a long negotiation period were critical to the exhibition's existence. I would also like to acknowledge the generous cooperation of Mr. Neil MacGregor, director of the National Gallery, London, in scheduling his institution's presentation of the Berggruen Collection to allow time for the Indianapolis exhibition as well. Such unselfish collaboration can only make us optimistic about the ability of museums to work together. I must also mention my admiration for the late Caroline Marmon Fesler, who presented the Indianapolis Museum of Art with its Gravelines canvas in 1945. It is the legacy of her connoisseurship that we honor with this exhibition.

Seurat at Gravelines: The Last Landscapes has also been enriched by the loan of several preparatory works, which are presented here as an ensemble for the first time. Thanks to a private collector in Tokyo and the Solomon R. Guggenheim Museum, the Indianapolis canvas can be examined in the company of its oil sketch and drawing. Generous loans from André Bromberg, the Victoria and Albert Museum, and an American private collection mean that three drawings for the Gravelines evening canvas can also be presented with the finished painting. And exhibited for the first time in this country is one of the three independent drawings from Seurat's summer in Gravelines, a loan from a private collection in Paris.

I am delighted to have the opportunity to commit to print my gratitude to Arthur G. Altschul and Samuel Josefowitz for their unflagging encouragement during the negotiations for *Seurat at Gravelines*. I would also like to thank Philippe Brame and Bernard Lorenceau, of Galerie Brame et Lorenceau, Paris, and Raymond Delahaye, historian in the Mairie of Gravelines, for their special assistance in the preparation of this exhibition and catalogue. There are many other people who were instrumental in the research and logistics for this exhibition; for their expertise and efforts I extend sincere appreciation to J. B. J. Bremer, Rijksmuseum Kröller-Müller, Otterlo; Françoise Cachin, Musée d'Orsay, Paris; Eric Darragon, Université François Rabelais, Tours; Marcel Laidez, Gravelines; Ronald de Leeuw, Rijksmuseum Vincent van Gogh, Amsterdam; Amaury de Louvencourt, Paris; David Nash, Sotheby's, New York; Jean-Louis Picard, Ader Picard Tajan, Paris; Anne Roquebert,

Musée d'Orsay, Paris; Scott Schaefer, Sotheby's, New York; Manuel Schmit, Galerie Schmit, Paris; John Tancock, Sotheby's, New York; Dominique Tonneau, Musée du Dessin et de l'Estampe Originale, Gravelines; Koji Yukiyama, The National Museum of Western Art, Tokyo. My thanks go also to the registration, conservation, and photography staff members at all the lending institutions.

Seurat at Gravelines: The Last Landscapes could not have been undertaken without the talents and resources of the Indianapolis Museum of Art community. First, I would like to thank the trustees and administration of the museum for allowing me to pursue this exhibition in the face of agonizing time constraints and the conflicting pressures of a major building program. Their recognition of the value of this exhibition, and its importance to the museum, was strategic.

I consider myself permanently indebted to the museum's new director, Bret Waller, who provided critical assistance to the catalogue even before his tenure as director began. William M. Butler, curatorial associate in the painting and sculpture department, is responsible for the Seurat biography and bibliography in this catalogue. He assisted me with virtually every aspect of the catalogue preparation, tackling the seemingly endless questions of documentation and organization with intelligence and awesome efficiency. Bill's prodigious research skills, sound judgment, and good humor made him the ideal ally for this project. *Seurat at Gravelines* was also well served by the considerable experience and inexhaustible energy of museum registrar Vanessa W. Burkhart, who supervised all loan logistics and every aspect of the federal indemnity program necessary for a project of this scope. My thanks go also to IMA exhibit designers Sherman W. O'Hara and Laura M. Jennings for their well-tempered combination of inspiration and restraint, so appropriate to the installation of a show devoted to Georges Seurat. I am very grateful to Susan Albers for her work on the National Endowment for the Arts grant application and to museum librarian Martha Blocker for her perseverance in tracking down endless interlibrary loans. I would also like to thank museum photographer Stephen Kovacik for his field work in Gravelines, undertaken with such enthusiasm, and for his assistance in preparing many of the catalogue materials. This project, as well as every other one we have undertaken since she came to the museum in February 1989, has been superbly handled by curatorial secretary Deborah S. Nicol, who has also keyboarded every change in each successive manuscript draft for this publication.

The catalogue for *Seurat at Gravelines* has called upon some of the most skilled eyes and minds in museum publications. I am very proud to have the work of art historian Jonathan Crary represented in this catalogue. His depth and breadth of vision in approaching the theories and applications of Seurat's aesthetic have enriched the Gravelines project. Once again warm thanks go to my friend and colleague Debra Edelstein, who has now survived our collaboration on a second Neo-Impressionist publication. Her editing prowess has always gone beyond syntax and style to a thorough grasp of the subject; and this time, if possible, I feel even more indebted to Debbi's comprehensive approach to publications and her commitment to excellence. I am grateful to publications manager Della Pacheco for

her astute organization of the catalogue production. Della's willingness to take on another project in the face of an already hectic publishing schedule goes beyond the bounds of professionalism or good sportsmanship. I have considered it a privilege to work with graphic designer Nathan Garland. From our first conversation about the Gravelines show, he showed an affinity for its concept that is reflected on these pages.

I have reserved special thanks for the IMA's senior painting conservator, David A. Miller. Several years ago, during one of our conversations about Seurat and Neo-Impressionism, it was David who first spawned the idea of a Gravelines reunion built around the IMA's canvas. I know that David shares the satisfaction I feel in seeing what began as a collegial "pipe dream" grow into a reality.

Ellen W. Lee
Senior Curator of
Painting and Sculpture

Introduction

Georges Seurat spent the summer of 1890 at Gravelines, a small French seaport near the Belgian border. There he painted four views of the town's narrow channel that were to become his last landscape works. Early the following year Seurat sent them to Brussels for exhibition at Les xx, and they were hanging in Paris at the Salon des Indépendants when he died in March 1891. Since that time the four paintings have never been exhibited together.

To mark the centennial of these works, and to enable them to be seen in relation to one another, the Indianapolis Museum of Art has organized *Seurat at Gravelines: The Last Landscapes.* A Gravelines reunion is a tempting prospect, if only for the occasion it affords to examine the beauty and technical finesse of each individual canvas. Yet the variety of color and composition evident in the Gravelines quartet, coupled with the systematic way in which Seurat habitually plotted his projects, suggests that there is special value in seeing these paintings as an ensemble. A large part of any exhibition's appeal is that fleeting opportunity to stand in the aura of an artist and sense something of the spark that brought life to inanimate objects. When that exhibition reunites intimately related, rare works of art, the occasion takes on added luster.

The reunion of the Gravelines seascapes of Georges Seurat, now dispersed worldwide, has that kind of allure. In Seurat's case the appeal is enhanced by the mystique of the artist himself, his tragically short life, and his enigmatic oeuvre. Few students of art have not been curious about the motivation of this reclusive painter who steadfastly pursued his own carefully prescribed aesthetic agenda. How many have not tried to imagine what the full range of Seurat's expression might have been had an average life span permitted his evolution through the Cubist, Expressionist, or Futurist eras? And while Seurat left an explicit statement of theory, each word of which has been thoroughly analyzed, the paintings themselves guard an ineffable quality that resists definition.

One hundred years after his summer sojourn in Gravelines, it is still possible to revisit the sites and frame the vistas that once engaged Georges Seurat. Despite devastating bombings, rebuilding, and questionable progress in the replacement of lighting and mooring devices, the geometric purity of the setting remains. Still standing is the elegantly conical form of the Gravelines lighthouse. Still intact are the sharp lines of the channel slicing through the harbor and the ramrod arms of the jetty that thrusts its way to the sea. New to the scene are the coastal cooling towers that make Gravelines one of France's largest nuclear power centers. One feels instinctively that had these shapes, in their elemental grandeur and their testimony to industrial development, existed in Georges Seurat's day, he would have felt compelled to paint them. It is evidence of the artist's power that such thoughts of his reactions and responses still fire our imagination.

Ellen W. Lee

The Four Gravelines Paintings

The Channel of Gravelines, Grand Fort Philippe, 1890
Oil on canvas
25 9/16 x 31 7/8 inches (65 x 81 cm)
Berggruen Collection
Catalogue number 1

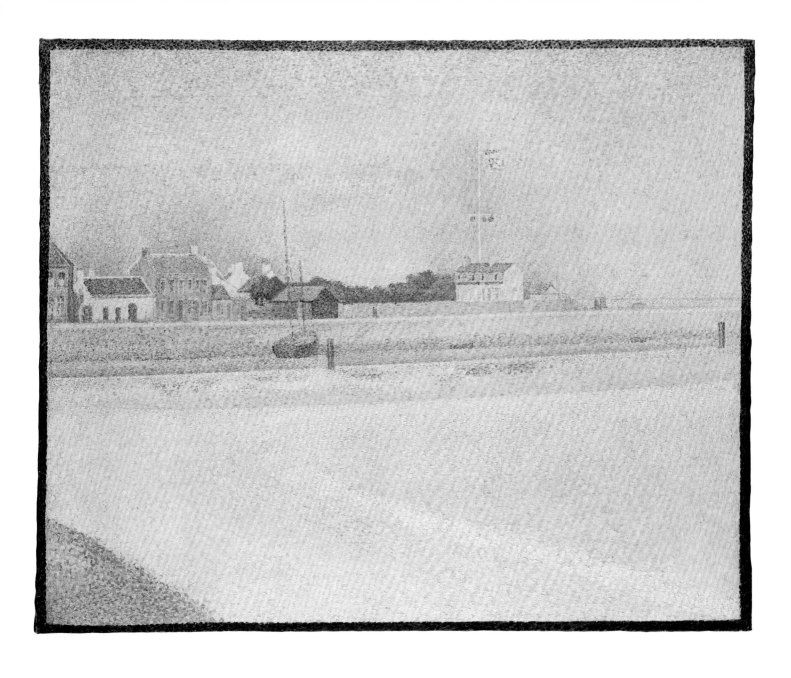

The Channel of Gravelines, Toward the Sea, 1890
Oil on canvas
28 ¾ x 36 ¾ inches (73 x 93 cm)
Rijksmuseum Kröller-Müller, Otterlo, The Netherlands
Catalogue number 2

The Channel of Gravelines, Toward the Sea, 1890
Oil on canvas
28 ¾ x 36 ¾ inches (73 x 93 cm)
Rijksmuseum Kröller-Müller, Otterlo, The Netherlands
Catalogue number 2

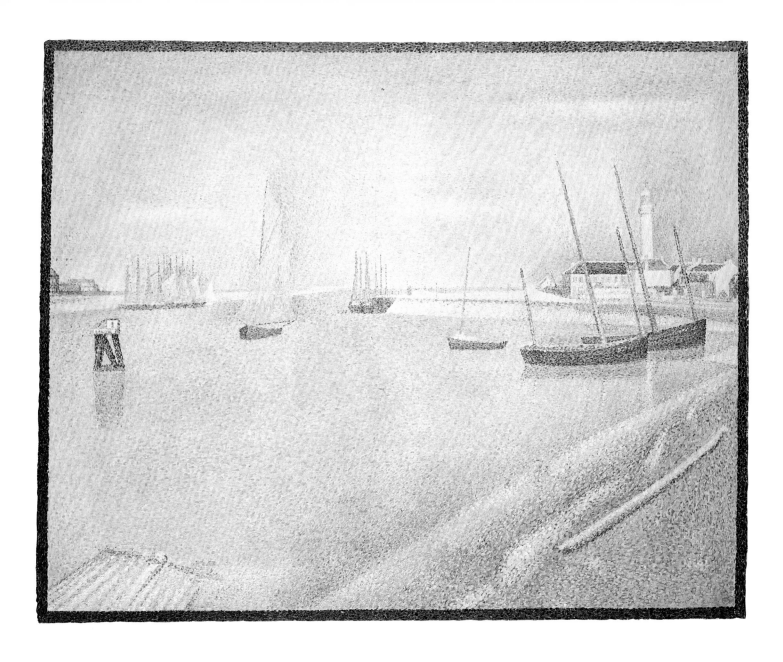

The Channel of Gravelines, Petit Fort Philippe, 1890
Oil on canvas
28 7/8 x 36 1/2 inches (73.4 x 92.7 cm)
Indianapolis Museum of Art
Gift of Mrs. James W. Fesler in memory
 of Daniel W. and Elizabeth C. Marmon
Catalogue number 3

The Channel of Gravelines, Petit Fort Philippe, 1890
Oil on canvas
28 7/8 x 36 1/2 inches (73.4 x 92.7 cm)
Indianapolis Museum of Art
Gift of Mrs. James W. Fesler in memory
 of Daniel W. and Elizabeth C. Marmon
Catalogue number 3

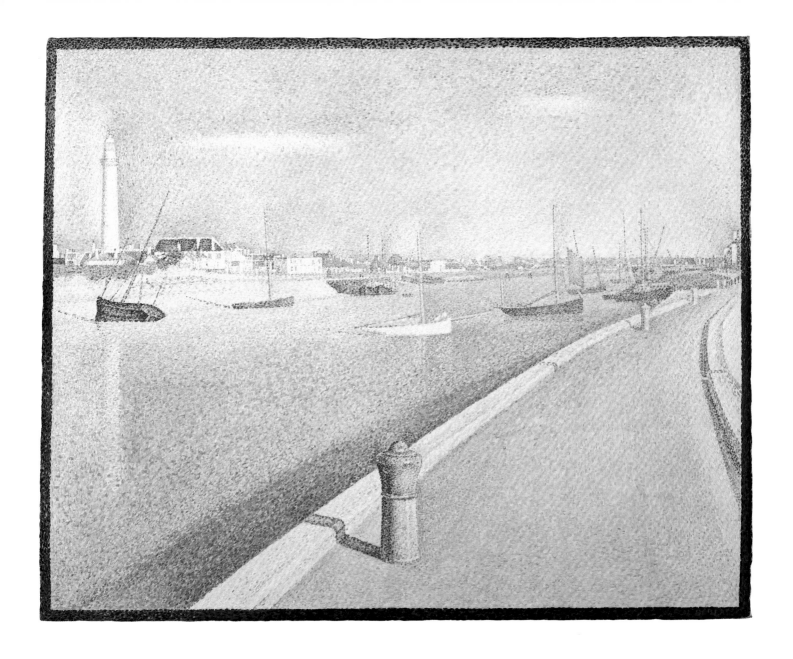

The Channel at Gravelines, Evening, 1890
Oil on canvas
25 ¾ x 32 ¼ inches (65.4 x 81.9 cm)
Collection, The Museum of Modern Art, New York
Gift of Mr. and Mrs. William A. M. Burden
Catalogue number 4

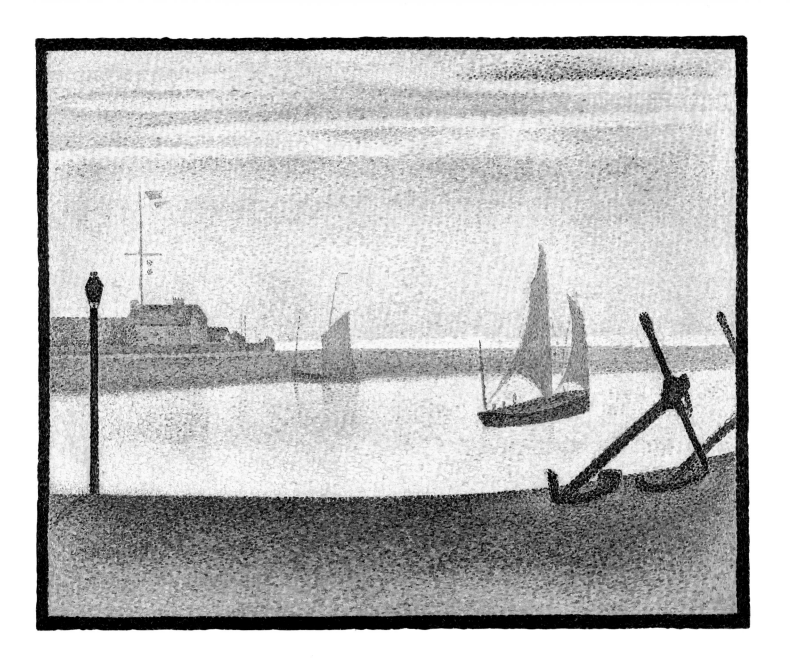

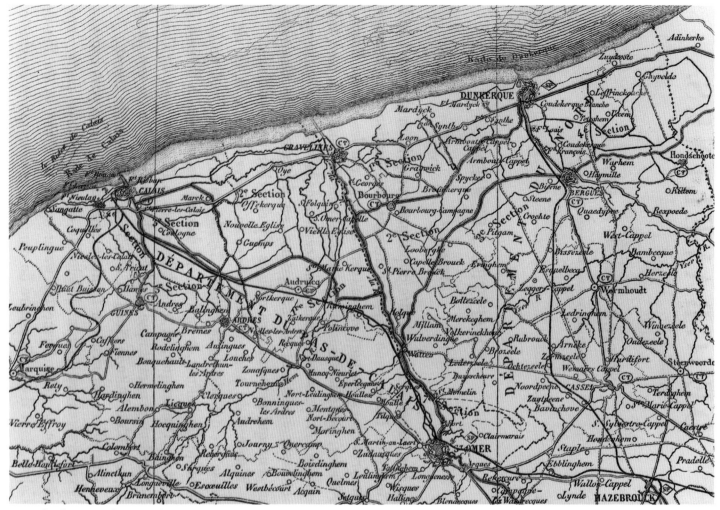

Map of Calais-Gravelines-Dunkerque, 1870s.

Seurat at Gravelines: The Last Landscapes

Ellen W. Lee

"Last week, when I spent a few days at Dieppe, I was thinking of him as I always do when I'm before the sea."[1] Nearly two decades after the death of Georges Seurat, a visit to the Channel coast still brought memories of Seurat to his friend and fellow Neo-Impressionist Charles Angrand.[2] His reflection is a wistful reminder of Seurat's attachment to images of the sea. For in the course of his brief career, Seurat devoted more than twenty canvases to the harbors and coastlines of France. Complementing the irony and enigma of Seurat's scenes of Parisian recreation[3] is the sense of harmony that pervades his marine paintings. Views of unpeopled ports and deserted beaches reveal an artistic imagination consistently drawn to the stillness and isolation that the sea can offer. In their mixture of reverie and restrained grandeur, the four Gravelines canvases give us good reason to sustain Angrand's association of Seurat and the sea.

Neither seaside fantasies nor composite views of picturesque sites, the marine paintings of Georges Seurat are records of specific locales, linked to the artist's summer excursions. In the short period he had to develop it, Seurat established a pattern of vigorous artistic activity in Paris during the autumn, winter, and spring, and reserved the summer months for sojourns on the Channel coast, where he went "to cleanse his eyes of the days spent in the studio and to translate as exactly as possible the luminosity of the open air."[4]

Seurat's first summer painting expedition took place in 1885, when he traveled to Grandcamp, a small coastal town in western Normandy. There he began to experiment with dotted brushwork, though his canvases were still very far from any steady reliance on pointillist handling. In 1886 Seurat chose the more active Norman port of Honfleur, at the mouth of the Seine, where the harbor, jetty, and beaches provided him with material for seven full-scale works. Painters such as Eugène Boudin, Gustave Courbet, and Claude Monet had preceded Seurat at Honfleur, making it the only one of Seurat's summer destinations with any significant artistic tradition. Seurat did not leave Paris for a painting excursion during the summer of 1887, perhaps because of obligatory military service in late August and September.[5] In 1888 he again traveled west along the Channel coast to the fishing village of Port-en-Bessin,[6] which offered the combination of rolling coastline and strictly defined harbor architecture that appealed to Seurat's design sensibilities. His six completed canvases are the work of a seasoned marine painter with a highly developed, individual point of view. Le Crotoy, a small Picardy port nestled in the bay at the mouth of the Somme River, northeast of Dieppe, was the site of Seurat's summer excursion in 1889. Since there are only two canvases which relate to this trip, his stay that year was probably brief.

In 1890 Seurat ventured even farther north, to Gravelines, a tiny seaport poised between Calais and the Belgian border, in the region where the waters of the English Channel meet the North Sea. Described by the 1894 edition of Baedeker's *Handbook for Travellers* as "an uninteresting town with 5952 inhab.,"[7] Gravelines was clearly not the choice of a painter seeking a fashionable resort or the camaraderie of an established artists' colony. Indeed, the port's obscurity may have enhanced its appeal to the reclusive Seurat, who had become increasingly protective of the originality of his methods and theories. The postscript on a letter to Félix Fénéon dated June 24, 1890, "I am going to the North around Calais?,"[8] punctuated by a question mark, suggests that the artist had not yet decided upon his exact destination. His correspondence confirms that Seurat was still in Paris in late June,

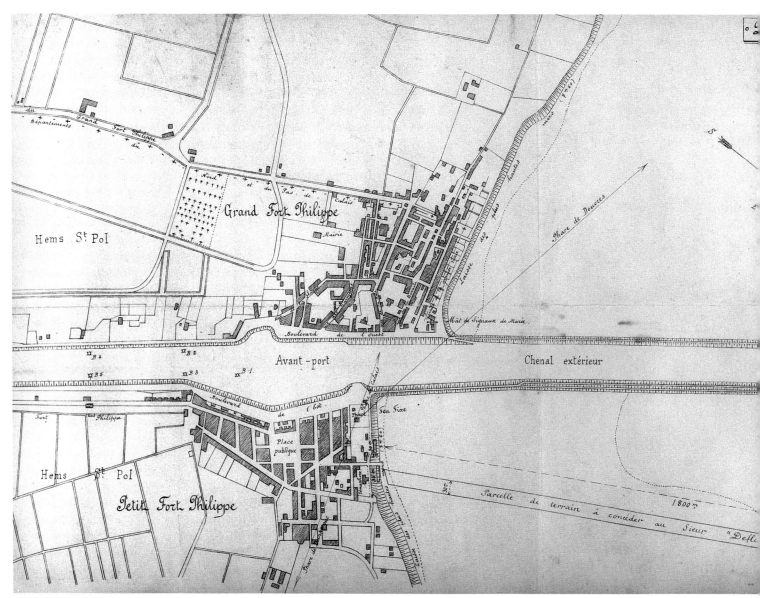

Map of the port of Gravelines, 1908, showing Grand Fort Philippe, the Gravelines channel, and Petit Fort Philippe. Just west of the channel is the cruciform indicating the signal mast (Mât de Signaux de Marée) and east of the channel is the rectangle marking the site of the lighthouse (Phare).

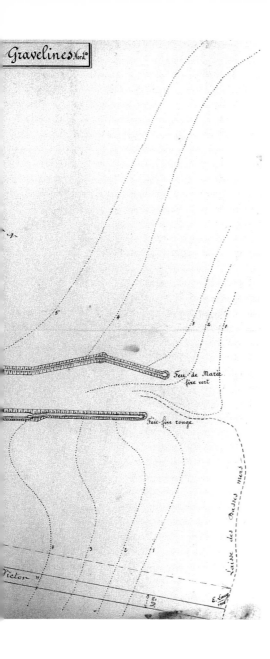

but his use of the present rather than future tense suggests that his departure was imminent. The specific dates of Seurat's arrival and departure, and whether he was accompanied by his mistress and infant son, have never been established.[9]

The four completed Gravelines canvases and a small group of oil sketches and conté crayon drawings are the only real evidence of Seurat's last summer painting expedition. Left to conjecture are such basic questions as Seurat's intentions for the relationship of the four paintings or the sequence of their execution. Like the marine paintings from other summers, the Gravelines canvases bear terse, unromanticized titles that are site specific, with only one reference to a particular time of day. Though Seurat never explicitly stated that the series has a certain sequence, examination of the lighting conditions and the artist's vantage points establishes that the *Grand Fort Philippe* canvas presents a morning scene, *Toward the Sea* is closer to late morning or noon, and *Petit Fort Philippe* is set in late afternoon. Seurat's painting of evening was clearly identified as such by its title.[10] It is likely that Seurat worked on several pictures concurrently, and he may well have completed them in his Paris studio.[11] In any case, there was no exhibition of the Société des Artistes Indépendants after Seurat's return to Paris in 1890, and the four Gravelines paintings did not appear publicly before their exhibition at Les XX in Brussels during February and March 1891. The catalogue for that show indicates that Seurat listed their titles in an order that corresponds to that same progression from early morning to twilight. He also exhibited the works, published in the same sequence,[12] at the Société des Artistes Indépendants show that opened on March 20, 1891. When Seurat died nine days later, his images of Gravelines were hanging there.

The site of Seurat's last marine paintings, Gravelines is a fortified town with a centuries-old history of military conflicts. Situated on the mouth of the river Aa, the Gravelines harbor is reached by a narrow canal or channel, which was widened and deepened in the seventeenth and eighteenth centuries. This channel links the port of Gravelines and the Aa with the English Channel and North Sea. Between Gravelines and the coast, to either side of this channel, are two small hamlets named in honor of King Philip IV of Spain: Grand Fort Philippe on the west side of the channel and Petit Fort Philippe on the east.[13]

Seurat's series of paintings and drawings is confined to these areas rather than to the town of Gravelines itself. Instead of offering a view out to the open sea or over the dunes that skirt the coast, each of the four pictures looks up, down, or across the same tightly circumscribed waters of the Gravelines channel. Indeed, the strict geometry of the canal's parallel lines seems ideally suited to the precisely organized compositions and surface patterns that Seurat favored. Within each painting, the channel slices through the scene, bringing a clear articulation of planes and razor-sharp order to these limpid views of skies and sea.

While Seurat explored the angles, vistas, and sunlight of this small maritime community, he did not feel bound to document its daily activities. In the 1890s the port of Gravelines saw steady traffic in trading and fishing vessels, and some visitors on holiday at the beach, yet Seurat consistently opted to paint its calmer moments, when few boats and even fewer people dared disturb the channel's tranquility. Eschewing scenes of leisure and labor alike, Seurat presented vacant wharves which, as Robert Herbert has phrased it, are "vacuumed clean of sociability."[14] The absence of figures only enhances the sense of Seurat as architect of the Gravelines ensemble, deftly manipulating sails, masts, and anchors in a pristine environment conveniently free of anecdotal distraction.

Though Seurat may have ignored such picturesque distractions at Gravelines, he was very attentive to factors of perception and color behavior, structure and pictorial harmony. A resolutely methodical artist, Seurat systematically pursued his own aesthetic agenda, often looking to scientific principles as the basis for his techniques. During the same summer that he painted the Gravelines canvases, Seurat codified his theory of painting in a letter to a friend. While this brief declaration (translated on page 51) is hardly a step-by-step outline for creating these pictures, the statement does offer insight into Seurat's goals and a guide to many aspects of design, color, and luminosity at work in the Gravelines series.

The last works to reflect Georges Seurat's rapport with images of the sea, the Gravelines quartet puts commonplace subjects at the service of uncommon virtuosity. Boats, beaches, even clouds assume colors of unnameable subtlety, brought into existence by deft brushwork and tones and tints of infinite nuance. From blond, morning sunlight to the pearly afterglow of twilight, the varied luminosity of Gravelines emanates from Seurat's canvases. In this final series of paintings, Seurat was rigorously faithful to the details of the actual landscape and to many of his systematic painting procedures. Yet in these canvases Seurat works an artistic alchemy capable of transforming seascapes into abstractions and inert pigments into tangible atmosphere.

View of Grand Fort Philippe, 1990.

House at Grand Fort Philippe, 1990.

The Channel of Gravelines, Grand Fort Philippe

With the retreat of the tides, this view of Grand Fort Philippe (page 17) actually becomes a landscape rather than a marine painting. From his vantage point on the dunes of Petit Fort Philippe, Seurat painted the shore at low tide, when the sea's recession leaves a broad, sandy expanse of beach in the foreground. Across the channel are the semaphore, flying its signal warnings of harbor waters too shallow for entry,[15] and the compact row of buildings that flanks the seawall on the channel's southwest side.

The spareness and simplicity of *The Channel of Gravelines, Grand Fort Philippe* show Seurat at his most disciplined. The thin blue stripe of the channel and the seawalls that parallel it divide the composition into two sectors of sky and sand. Seurat tipped the strong horizontal axis slightly upward on the right, avoiding the complete stasis of an absolutely level horizon line. Only a painter with great spatial sense could assume, correctly, that one diminutive mooring post might anchor the entire right side of the composition.

The patch of grass at lower left has a triangular shape that is one of Seurat's basic compositional elements. Visible in the last figure paintings,[16] as well as many of Seurat's marines, is the placement of a triangular motif in a lower corner. Here the diagonal axis set by the grass is reinforced by a narrow band of white on the beach. Seurat's predilection for such compositional devices can be understood in light of an observation by David Sutter, one of several aestheticians whose maxims were closely studied by Seurat. In an article of 1880 the Swiss theorist wrote that "oblique lines have the function of creating a harmony between the horizontal and the vertical."[17] The Gravelines series offers several examples of Seurat's reliance on the hypotenuse to harmonize the inevitable turns from vertical to horizontal that occur in any rectangular schema.

While the small triangle of grass has a key compositional role, it is not a fabrication. Period photographs show that vegetation once covered the low dunes descending to the Petit Fort Philippe beach, and framing a vista from that vantage point produces the sharp shape of the lower left corner. Thus the grass can also be considered an example of Seurat's fidelity to the existing landscape. An even clearer indication is the pale yellow house in front of the semaphore. This structure, with its slate-shingled mansard roof, still stands, and a recent photograph shows that the artist even respected the irregular placement of its two chimneys.[18]

Seurat's deserted channel basks beneath the blond light of a North Coast morning. That it is indeed morning is confirmed by the fact that the east side of the yellow house is bathed in sunlight and by the absence of the shadows which would stretch below the two bollards in the afternoon sun. While Seurat based his harmonic structure on vibrant, contrasting hues, the Gravelines paintings demonstrate a reliance on gentler colors and pastel tints. The poet and critic Emile Verhaeren perceived the distinction, noting their "harmony born just as successfully from a combination of light and blond tints as from strong and vibrant ones."[19]

At first glance the beach appears blanketed in a uniform caramel color, but closer inspection reveals it to be one of the finest examples of the exquisitely subtle differentiation of tone and tint that distinguishes the Gravelines series. The sandy

shore was an ideal candidate for Seurat's deft use of gradation, one element in his treatment of color, which calls for "the juxtaposition of hues or values close to each other on the chromatic circle or value scale."[20] Seurat dotted the foreground with many shades of gold to indicate the local color of the sand. Also present are several variations of yellow and rose, the warm hues which, according to standard Neo-Impressionist practice, record the sun's action upon the landscape. The richness and fine nuance generated by this use of related colors and tones are compounded by the dotted application of paint, which contributes to the shimmering effect that distinguishes Neo-Impressionist paintings. Blue and green tints, which add depth to the rather flat foreground, grow more dense in the fan-shaped area on the right side of the beach, coloring the sand as if the last drops of surf were still glistening upon the shore.

Similarly, the delicate blue sky is actually a complex membrane of color. Several shades of blue, often flecked with white, coexist with the yellow tints that indicate the presence of sunshine, while an exquisite rose hue traces the wisps of clouds stretching along the Gravelines horizon. An intensification of blue pigments over the buildings on the left complements their orange roofs, illustrating the divisionist principle that the area of greatest contrast should occur at the junction where two zones of color meet. In their tart brilliance the painting's two dominant areas of green establish another diagonal element, as the eye moves inevitably from one green zone to the other.

The Gravelines marines were the first to bear Seurat's dark painted borders.[21] Although deep blue hues predominate, the dotted perimeters are far from monochromatic. Shifts in hue occur frequently, as Seurat varied the pigments to contrast with the different colors adjacent to the border. Consistent with the Neo-Impressionist use of complementary hues, the upper border of *Grand Fort Philippe* is dotted with orange, the opposite on the color wheel from the blue tints that prevail in the sky. Below the green grass, reddish purple dots appear, only to give way to blue beside the blond tints of the beach.

While Seurat never indulged in the lavish brushwork of the Impressionists, his more uniform surface texture still allowed him to accentuate the intricacies of his patterns. Within the beach area is a barely perceptible wedge-shaped configuration, created by the white band on the shore and the changing directions of Seurat's facture. There the short strokes that parallel the horizontal axes of the sea wall and lower border gradually bend into an unmistakable v-shape, with its vertex pointing to the truncated left edge of the sandy basin. The diagonal strokes adjacent to the grass also contribute to this formation. Like all of the pictures in the Gravelines series, this canvas also reflects Seurat's meticulous "steering" of the brushwork around the perimeter of the image. Along the upper border, horizontal strokes prevail in the sky, but at the painting's left and right edges the brushwork gradually changes course to parallel the sides. A comparable alignment, and realignment, occurs in the lower left and right corners. Such attention to the placement of these small strokes, which are far from uniform in shape or size, belies the notion that Seurat's application of pigments was a mechanical, repetitive exercise. Subtly cushioning the strict linear elements of the vacant port, these delicate touches of the brush bathe the compositional severity of *Grand Fort Philippe* with mild air and light.

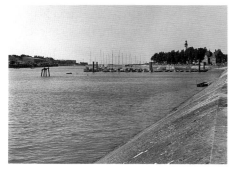

View of the Gravelines channel at the Flaque des Espagnols, 1990.

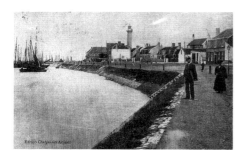

Shore of the Flaque des Espagnols, Petit Fort Philippe, Gravelines, ca. 1900.

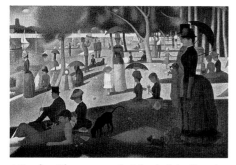

A Sunday Afternoon on the Island of the Grande Jatte, 1884–86. Oil on canvas, 81 x 120 ⅛ inches (207.6 x 308 cm). The Art Institute of Chicago. Helen Birch Bartlett Memorial Collection. (© 1990 The Art Institute of Chicago, All Rights Reserved)

The Channel of Gravelines, Toward the Sea

In a dramatic change from the parallel horizontal bands of *Grand Fort Philippe*, the elements of this composition plunge deep into the picture plane (page 19). Instead of a view across the narrow canal, the canvas presents the vista from the Gravelines channel toward the open sea.[22] Seurat's vantage point is the Flaque des Espagnols, or pool of the Spaniards, named for those who occupied the region during the early seventeenth century.[23] This outer harbor area breaks the relentlessly straight lines of the Gravelines canal by jutting out on the Petit Fort Philippe bank to a point northeast of the normal canal border. Across the channel on the left are the semaphore and houses seen more directly in *The Channel of Gravelines, Grand Fort Philippe.*

A photograph taken in 1990 establishes again how faithfully Seurat has recorded the Gravelines sites (top). Still visible on the right is the lighthouse, built in 1837–38, and the sharp angle formed by the wharves at the Flaque des Espagnols. On the left of the photograph is a channel marker, used to inform sailors of the water's depth, which also appears in Seurat's canvas. Though the marker in the photograph no longer bears a number, the 1908 map (page 26) of the Gravelines channel indicates that it formerly occupied the position labeled number one, as it does in the painting. The broad green embankment at the lower right corner might seem the result of Seurat's fondness for the triangular compositional device, yet the photograph illustrates that this slope is also specific to the locale. It would not even be fair to say that Seurat exaggerated the angle of incline, as at this area of the Gravelines channel the descent to the water is precipitous (middle).[24] With its combination of angular seawalls, sloping embankment, and conical lighthouse, the setting offered the geometric rigor certain to engage Seurat's sense of pattern.

Based on a variation of a diamond-shaped format, *The Channel of Gravelines, Toward the Sea* is the most complex and unorthodox composition of the quartet. The artist positioned himself so that the cut of the basin was at its deepest; it races to a point beyond the right edge of the composition before turning sharply to the left, toward the channel outlet. The slanted masts of the two larger boats, in their parallel alignment, help propel the eye back toward the center of the scene. They also balance the lower right corner, whose diagonal thrust is accentuated by the log that parallels this axis.

Reinforcing the third edge of the diamond and creating a sense of movement unusual in the Gravelines series is the large vessel with pink sails, returning to the harbor. In its strategic placement the boat has much the same effect of implied movement as the mother and child walking toward the viewer in the center of *A Sunday Afternoon on the Island of the Grande Jatte.* The channel marker and its reflection then draw the eye along the last leg of the circuit, toward the raft or wooden-slatted dock. Its cropped view and placement below the large sailing vessel suggest progression beyond the confines of the composition.

The Channel of Gravelines, Toward the Sea sustains that sense of mild, blond North Coast sunlight characteristic of the Gravelines works. The scene appears to be late morning or noontime, as those portions of the lighthouse and buildings on the right which are exposed to direct sunlight or cast in shadow suggest that the sun is high in the eastern sky. The color scheme is dominated by Seurat's subtle differentiation of the luminous blue skies and the greener coloration of the channel waters. With a chromatic role comparable in importance to its compositional one, the vessel entering the harbor brings its rose-colored sails into lively contrast with the surrounding sky and sea.

Although Seurat's pointillist brushwork has the overall effect of uniformity, this canvas also reveals the considerable latitude possible within the technique. The artist chose a very fine dot for the distant structures on the left but adopted a patchier handling for the white buildings near the lighthouse. As in *Grand Fort Philippe* Seurat often changed the direction of entire streams of small strokes, gradually shifting the currents of surface texture to reinforce the broad compositional divisions. The points of blue pigment stippled around the silhouettes of the masts and lighthouse emphasize their contours and enhance our sense that these sharp elements are piercing the diaphanous atmosphere of the coast.

The Channel of Gravelines, Petit Fort Philippe

For *The Channel of Gravelines, Petit Fort Philippe* (page 21), Seurat crossed to the west side of the channel and framed a vista looking inland toward the harbor, rather than out to sea. The painting's title refers to the view across the channel at the shore of Petit Fort Philippe and its lighthouse. Again the artist has depicted the active harbor in a period of tranquility, infusing what might have been a picturesque marine painting with the stillness and detachment that mark it as the work of Georges Seurat.

A small preparatory oil on panel sketch (page 34) holds several clues to the evolution of the finished canvas. In the study a two-masted vessel placed parallel to the quay dominates the composition. This boat was eliminated in the final version of the canvas, though it is similar in type, rigging, and orientation to the vessel that figures in *Grand Fort Philippe*. Seurat opted instead for the sturdy form of the bollard, which divides the canvas in half and occupies the lower portion of the picture with unquestionable authority. With this resolution of the foreground treatment, Seurat tempered the diagonal axis, moving the composition toward greater balance and away from any further suggestion of movement. What appears in the study as a cluster of loose blue strokes in the middle of the far shore reappears in the final version as a large boat, listing to the right, now moored directly under the lighthouse. This placement allowed Seurat to complete (or initiate) the deft horizontal pacing of the various vessels across the channel, reinforcing the flat line of the horizon and the scene's mesmerizing calm. In the finished painting the artist also trimmed the proportion of the walkway in order to expand the breadth of the channel and its role in the composition. As a result, the pictorial weight of *Petit Fort Philippe* is more evenly divided among the three areas of sky, sea, and path.

Not present in the oil sketch is a small, white-hulled boat which occupies the center of the finished painting. The only known drawing for *Petit Fort Philippe* is devoted to this small vessel. *The Clipper* (page 35) is composed primarily of straight strokes of conté crayon that cut across the laid lines of the Michallet paper. As in some of his most evocative figural drawings, Seurat allowed white areas of the paper to emerge as critical elements of the image. In this manner, both the boat's hull and several buildings behind it are defined. The subtle massing of light and dark in the background is not just a vague indication of setting; the light strokes of the crayon compare quite closely with the structures on the far shore of the canvas, suggesting that by this stage Seurat had made very specific plans for the boat's orientation within the final composition. To the immediate right of the boat's mast is a shower of dark, vertical lines demonstrating Seurat's approach to irradiation, another element in his treatment of contrasting light and color. The law of irradiation holds that when two neighboring areas of unequal lightness meet, their differences will seem the most pronounced at their common edge.[25] Thus when Seurat applied dark strokes adjacent to the white mast, the contrast underscored its form and contour. In the finished canvas, this effect appears as a cluster of blue pigments beside the yellow mast, or as the concentration of blue tints to the right of the bright, white edge of the lighthouse.

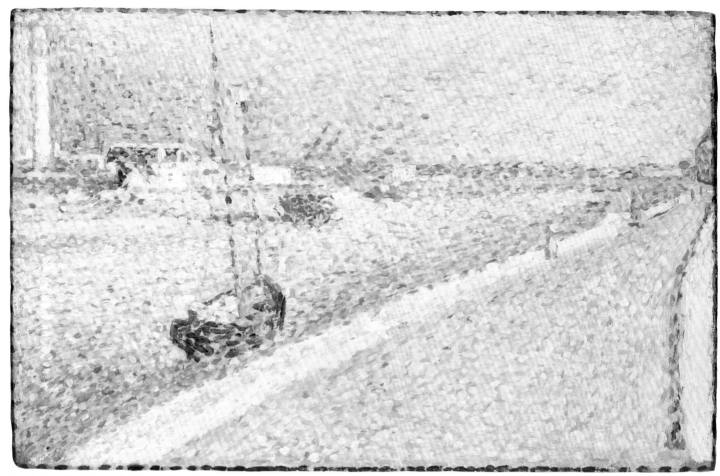

Study for *The Channel of Gravelines, Petit Fort Philippe*, 1890. Oil on panel, 6 3/8 x 9 7/8 inches (16 x 24.7 cm). Private Collection, Tokyo. (cat. 5)

The Clipper, 1890. Conté crayon on
Michallet paper, 9 ¼ x 12 ⅜ inches (23.5 x
31.5 cm). Solomon R. Guggenheim
Museum, New York. Gift of Solomon R.
Guggenheim, 1937. (cat. 7)

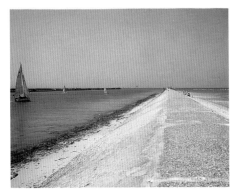

View of the Gravelines channel jetty, 1990.

View of the Gravelines channel, with Petit Fort Philippe on the left and Grand Fort Philippe on the right, 1990.

Three other conté crayon drawings (page 78) from Seurat's summer at Gravelines have often been classified as studies for *The Channel of Gravelines, Petit Fort Philippe*. Each drawing shows one or more boats sailing along the narrow channel inlet. The receding lines on the right side of each composition have sometimes been mistaken for the rose and yellow walkway that sweeps inland in the finished painting. In fact, Seurat rendered these drawings from the opposite shore, and his plunging diagonal strokes actually define the rigid east arm of the jetty that reaches out into the sea (top). Therefore the drawings are actually independent works, not preparatory studies for any of the Gravelines canvases.

The Channel of Gravelines (page 37) offers the longest perspective of the trio, racing down the jetty toward the signal light and the open sea. Seurat accentuated its forceful diagonals by fanning them across the entire sweep of the foreground. This device and the staggered positions of the sailboats establish a sense of movement absent in the Gravelines canvases. Seurat needed only a few strokes of the crayon to distinguish sky from sea from jetty; and this seascape, pared to its unpicturesque essentials, is another indication of the restricted range of subjects and forms that Seurat allowed himself in the Gravelines works.

Alterations from preparatory works to finished canvas indicate that Seurat often fine-tuned his works by manipulating elements such as the boats' masts and hulls, or his own vantage point, rather than adjusting the architecture of the harbor. In *The Channel of Gravelines, Petit Fort Philippe* Seurat wove a composition of the most delicate equilibrium, balancing the strong horizon line and the chain of small boats with vertical elements such as the bollard, the lighthouse and its reflection, and the spindly masts of the sailing vessels. Animating the scene is the broad promenade along the wharf. Movement deep into the picture plane is accomplished not by a sharp, jagged turn into space (as in *Toward the Sea*) but by means of a smooth, sweeping curve. This energetic swing also occurs in Seurat's figurative work of the period, notably in *The Chahut* (page 52) and Seurat's final painting, *The Circus* (page 52). In the latter Seurat also repeated his use of a central vertical element, replacing the bollard so prominent in the Gravelines canvas with the clown figure that leads the viewer into the activity of the circus ring.

Seurat's demonstrated fondness for this curving compositional device might lead one to conclude that it was an invention of the artist, but a photograph of the Gravelines site confirms that nature again provided Seurat with the raw materials (bottom). He framed his scene at the point where the promenade does indeed appear to bend away from the quay. The photograph also shows that the arcing stream of deeper blue pigments echoing the curve of the wharf is not just a decorative motif invented to reinforce the surface design. It depicts the shadow cast in the channel during late afternoon. Another indication of the artist's fidelity to the specifics of his locale lies deep within the painting. Barely perceptible on the far shore of the canal are two inverted v-shaped forms which are actually channel markers (see the markers designated B1 and B3 in the map on page 26). With little compositional function, and virtually invisible to anyone not familiar with Gravelines, the channel markers represent Seurat's impulse to maintain the integrity of his subject.

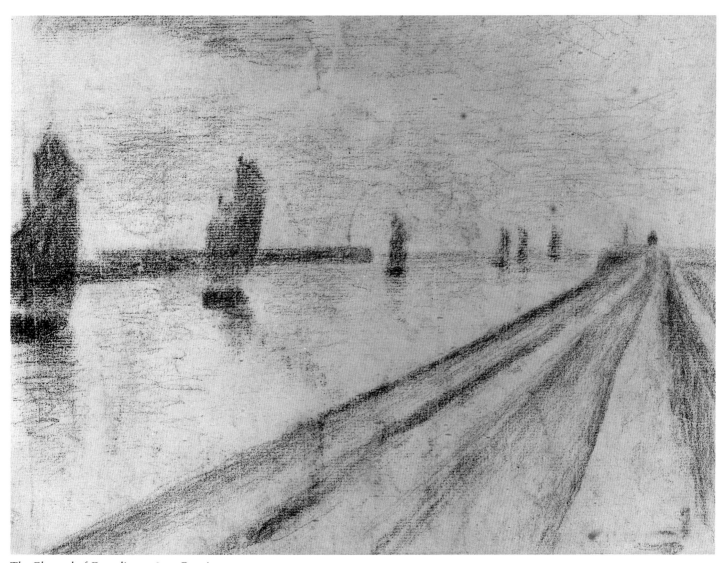

The Channel of Gravelines, 1890. Conté
crayon on Michallet paper, 9 5/16 x 12 3/16
inches (23.5 x 31 cm). Private Collection,
Paris. (cat. 16)

Within the meticulously transcribed, balanced world of *Petit Fort Philippe*, Seurat has managed to apply brush strokes of surprising variety and irregularity. The measured facture of pointillism has been squeezed and stretched to fine points, longish dashes, and broad patches. Their density varies from the tight network concentrated in and around the bollard, and perhaps contributing to its rather insistent presence (page 39), to the much looser treatment on the right side of the sky, where the white ground layer occasionally appears beneath the broader strokes. Placement of the brushwork is also far from uniform, as Seurat again negotiated the corners with horizontal and vertical strokes and reinforced the sweeping curve by the bands of dots parallel to the curb. Above, subtle changes and reversals in brushwork float like currents of air through the summer sky.

In this canvas Seurat recreated the North Coast light with a gentle oscillation of color, again using the pointillist technique to suggest the nuance of tone and tint that exists within a deep shadow or the most fragile reflection. As indicated by the direction of the shadows cast on the curb[26] and in the water, Seurat chose a late afternoon setting, when these deep-toned shapes could figure into the architecture of his composition. The summer sun seems at its most powerful in this Gravelines picture, where the curb is bleached a stark white and dots of yellow pigment collect at its edges. Under the sun's intense glare, the bollard reflects the full gamut of exposure, from direct light to shade. Seurat's sensitivity to the behavior of light demonstrates that, like the Impressionists, he was attentive to the effects of weather conditions or time of day. Yet *The Channel of Gravelines, Petit Fort Philippe* exudes a sense of harmony that removes it from the specifics of a certain moment or season and places it rather in an idealized, timeless realm. Just as no stray weed is allowed to grow on Seurat's pristine walkway, no strolling figures introduce the notion of quotidian existence into this controlled environment.

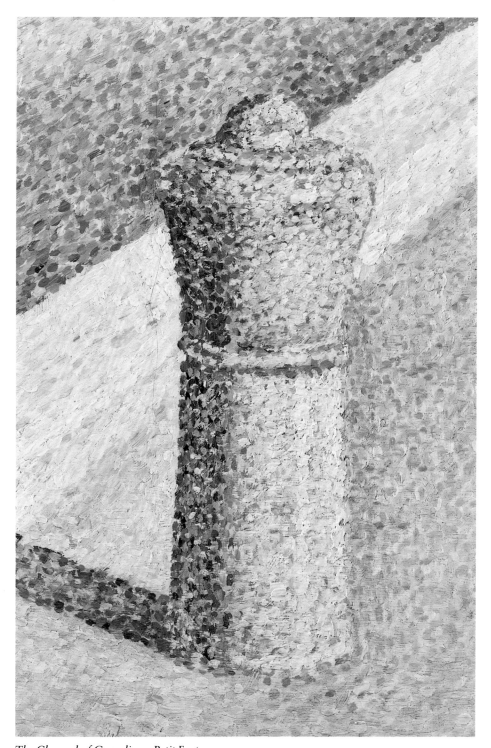

The Channel of Gravelines, Petit Fort
Philippe (detail, actual size).

The quay at Petit Fort Philippe, with Grand Fort Philippe in the distance, ca. 1900.

The Channel at Gravelines, Evening

For the last member of the Gravelines quartet (page 23), Seurat abandoned the shimmering blond atmosphere of day for the pearly tones and saturated hues of summer twilight. Instead of the sweeping curves, taut diagonals, and sharp angles that brought a degree of animation, however controlled, to the other Gravelines scenes, Seurat insulated this composition with layers of horizontal bands. In the foreground is the Petit Fort Philippe side of the quay, followed by the Gravelines channel and the opposite shore, and finally, in the distance, the silvery-green waters of the English Channel.

Like *The Channel of Gravelines, Grand Fort Philippe* (page 17), this scene was painted from Petit Fort Philippe, but for this canvas Seurat moved closer to the channel, onto the quay itself, and rotated his view a few degrees to the west. Present in both canvases are the semaphore and the house with its distinctive roofline. A period photograph of the channel shows the gas lamp (at lower center) and the gentle curve of the wharf, both of which Seurat repeated in his canvas, again demonstrating that elements easily taken for design features actually have their sources in the landscape itself.

The largest body of preparatory works for any of the Gravelines series, one oil sketch and four conté crayon drawings, has been identified with this canvas. By the time he executed the oil on panel study (page 41), which at 6 ³⁄₈ by 10 inches is smaller than any of the drawings, Seurat had established the scope of the image, its basic horizontal structure, and the relationship of semaphore, house, and street lamp. The vertical forms in the center of the sketch, presumably tall sails and their reflections, were later eliminated. Also indicated at this stage were the general color and tonal schemes, applied in the form of small, primarily horizontal touches over a white priming layer. Unlike the other oil sketches from the Gravelines corpus (pages 34, 76, 77), this panel painting has no border.

One of the conté crayon drawings (page 42) prefigures the left half of the finished canvas, as it shows the addition of two boats, one with sail and one without. The cloudy sky is hastily sketched with hatchings in criss-cross and chevron patterns that bear no particular resemblance to the striated sky of the canvas. While the Gravelines drawings are not characterized by the rich blacks and the sense of contrast that distinguish Seurat's most evocative independent works on paper, this drawing does reveal his attention to tonal distinctions. The lamppost is the darkest element of the drawing, a role it maintains in the finished canvas. A curious element on the right side of the drawing is the subtle band of vertical lines that descends from a dark spot just below the far shore. It suggests that the artist was assessing the effect of a vertical addition to this area.

In fact, in another drawing (page 43) devoted to the central and right sections of the finished painting, vertical elements do appear in the form of a two-masted boat moored at the near shore. The masts stretch up forcefully to the top of the composition, interrupting the picture's horizontal hegemony. This particular motif, however, was not maintained in the oil version. Another addition in this drawing is a partial view of a pair of anchors, elegantly aligned parallel to one another at the paper's right edge. The horizontal strokes that sweep across the paper and expose the laid lines in the foreground suggest rapid, unhesitating execution. Even here,

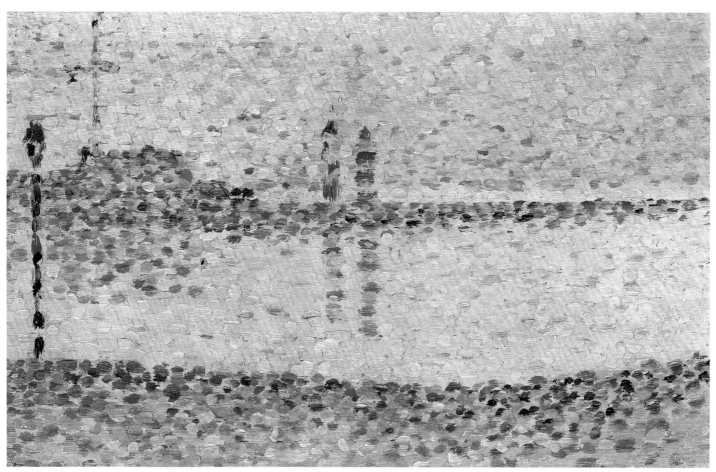

Study for *The Channel at Gravelines,*
Evening, 1890. Oil on panel, 6 3/8 x 10 inches
(16 x 25.2 cm). Musée de l'Annonciade,
St. Tropez. (cat. 6)

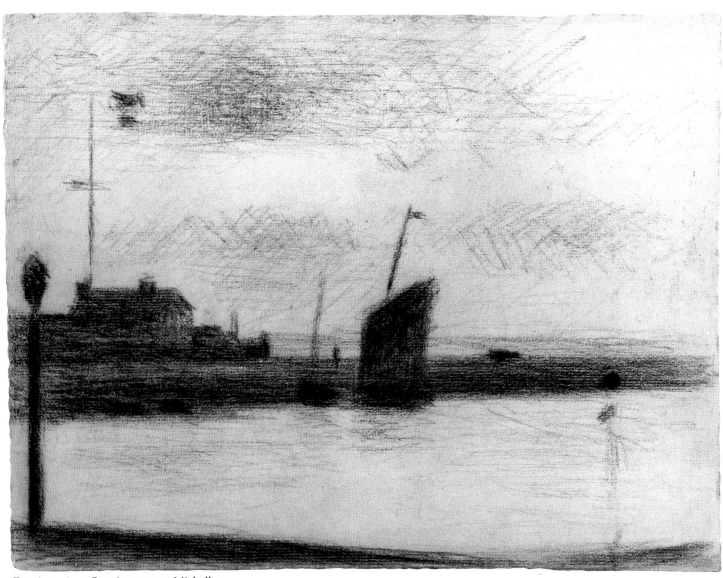

Evening, 1890. Conté crayon on Michallet
paper, 9 7/16 x 12 5/16 inches (24 x 31.2 cm).
André Bromberg Collection, Paris. (cat. 8)

Boats and Anchors, 1890. Conté crayon on
Michallet paper, 8 ¾ x 11 ¾ inches (sight)
(22.2 x 29.8 cm). Private Collection, USA.
(cat. 9)

however, Seurat's instinct for contrast prevails, as demonstrated by the subtle play of light against dark in the foreground. A small area of white, exposed paper appears below the boat's black hull, while to left and right, beneath the lighter zone of the channel waters, Seurat has reinforced the dark tones. In its clear opposition of horizontal and vertical, light and dark, the surface pattern of Seurat's drawing flirts with abstraction.

The pair of anchors takes on added prominence in a third drawing (page 45), where their actual placement on the jetty is also more specifically articulated. The anchors now appear in a format very similar to that in the final canvas. In this sketch the simplicity of the horizontal bands appears as a foil for the dynamism and calligraphic intricacy of the anchors' diagonal bars. They intersect the composition, linking near shore and distant sky and initiating lines of vision that lead the viewer beyond the picture plane. When Seurat applied oil to canvas, the velvety blackness of the anchors was translated into the rich contrast of warm red versus cool blue-violet pigments.

From a fourth drawing (page 46) Seurat extracted a larger sailboat and with barely a change in detail or orientation placed it to the left of the anchors in the finished canvas. The setting for this sketch, with its diagonal lines at lower right, indicates that originally this vessel was situated along the outer arm of the jetty. The drawings and the oil sketch for *The Channel at Gravelines, Evening* reconfirm Seurat's practice of refining his compositions by adding, subtracting, or substituting what John Russell called "the items of marine furniture which gave an epigrammatic finality to compositions thought out to their smallest detail."[27]

As the harbor architecture and its nautical accoutrements coalesce, they form a composition of balance and serenity. The horizontal banding of shore and water is continued in the colorful streaks of clouds across the sky. Intersecting these parallel planes are the lantern, house, semaphore, anchors, and "smaller masts of boats," which, as painter Jean Hélion described it, "dance a variation around their verticality [and] travel on the edge of obliqueness."[28] These motifs have been deftly balanced and counterbalanced so that the left and right sides of the canvas acquire a relatively even pictorial weight. The surface texture also contributes to the seamless congruity of the scene. From semaphore to anchor, from lamppost to the most delicate mast, every compositional element has been delicately silhouetted by parallel brushwork that accommodates and acclimatizes, weaving each new member of the image into this membrane of light.

With its pattern of horizontal bands, gradations of color, and deft emphasis upon the silhouettes of anchors and sails, Seurat's evening view of Gravelines also reflects his familiarity with principles of *japonisme*. Like many of his Impressionist and Neo-Impressionist colleagues, Seurat was moved by the examples of Japanese prints, which were widely exhibited in Paris in the 1880s. As early as 1885 one of his summer seascapes from Grandcamp betrayed a startling resemblance to a print by Hokusai.[29] And in a more general sense, Seurat's own affinity for the purified, synthesized landscape, devoid of extraneous detail, must have attracted him to the abstraction and simplification of Japanese prints.[30]

The Anchors, 1890. Conté crayon on
Michallet paper, 9 ⅜ x 12 ⅜ inches (23.8 x
31.5 cm). Board of Trustees of the Victoria
and Albert Museum, London. (cat. 10)

Sailboats, 1890. Conté crayon on Michallet
paper, 9 ¹⁄₁₆ x 12 ³⁄₁₆ inches (23 x 31 cm).
Henri Cachin, Paris. (cat. 11)

The compositional balance and harmony of *The Channel at Gravelines, Evening* are reinforced by its color scheme, as the shifts in hue and tone correspond to the changing bands of the composition and image. Further, the lamp and anchors, with their combination of deep saturated blues and brilliant red-oranges, represent the picture's greatest chromatic weight, and their placement helps define the pictorial space, marking the left and right sides and delineating the edge of the foreground plane. The sails which give definition to the middle ground seem to exist behind an atmospheric veil, paler than the foreground elements but more vibrant than the opalescent pigments in the distance. Nowhere is the advantage of Seurat's pointillist technique more evident than in the cloudy evening sky, where exquisitely subtle variations of muted rose, blue, and green conjure up the palette of sunset.

Virtually unprecedented in Seurat's oeuvre, however, is his coloration of the wharf. The lowest area burns with glistening tesserae of primarily yellow and orange hues that diminish in size and warmth as they recede. At the channel's edge the pigments form an almost iridescent zone of mauve, orange, and deep blue hues that create a clear line of demarcation with the pastel tones of the water. Unlike other luminous features in the Gravelines series, the lower foreground plane of this evening scene cannot be accounted for on a naturalistic basis such as direct exposure to vibrant sunlight or glowing gaslight. The unusual coloration heightens the painting's evocative mood and establishes a contrasting element with the composition's dark lower border. In fact, Seurat's dark perimeter seems at its most harmonious in this canvas. Its deepest hues find their chromatic mates in the lamppost, the anchors, and the wharf beneath them, and the dark blue margin becomes an apt harbinger of the darkness that is about to descend.

With its hushed tones and picturesque setting, this last member of the Gravelines quartet seems to carry the series' strongest suggestion of mood. Instead of the sunshine that defined each element of the harbor architecture in the other canvases, laying bare the details of boat or bollard, the diffused light of evening envelops the familiar forms of the Gravelines channel, casting them as silent players in a subdued nocturnal drama. In *The Channel at Gravelines, Evening* Seurat's mingling of light and shape continually renews itself upon the delicate curve of the channel proscenium.

Seurat and the Gravelines Frames

Seurat did not consider the Gravelines paintings finished at the edge of their images or even at their dotted borders. Like Degas, Whistler, and Pissarro, Seurat experimented with various framing techniques throughout his career, and he executed frames specifically for the Gravelines seascapes. Seurat considered the issue of sufficient importance to include it as the final phrase in his 1890 statement of theory, stipulating that the frame should continue the painting's contrasts of value, hue, and line.[31] Designed to insulate and enhance the paintings' color schemes, Seurat's frames were not independent decorative elements but integral parts of the harmonic whole.

Unfortunately, no member of the Gravelines ensemble still bears its original frame, and speculation about Seurat's intentions is based largely on contemporary accounts and the clues provided by the dotted borders. The narrow pointillist border painted directly on each canvas functions as a transitional element, initiating the inevitable breaks between the image, its painted frame, and the surrounding environment. The deep ultramarine blue that dominates the Gravelines borders establishes the contrast with the delicate tones of all four works, as the entire gamut of the series' luminosity is enhanced by Seurat's use of these dark perimeters. He varied the other vibrant pigments in the borders according to the hues found in the adjacent areas of the image. Consistent with his reliance on complementary colors, Seurat applied orange as the opposite of blue, red as the complement of green, and, less frequently, yellow opposite violet.

The frame for *Le Crotoy, Looking Downstream* (page 49), one of the few originals not discarded over the years in favor of traditional gilded moldings, documents Seurat's approach to framing at the end of his career. Painted one year before the Gravelines series, this vibrant frame is animated by points of contrasting colored pigments. While the border seems to depend less on the deep blue tints, the frame does demonstrate Seurat's practice of extending the dotted treatment of the border onto the flat surface of the frame itself. With this example and the colored border as guides, a dark blue frame, flecked with bright pigments, was fabricated for *The Channel of Gravelines, Petit Fort Philippe* in 1982.[32]

Seurat's colleagues and critics were alert to the evolution of his framing techniques, and they have provided vital documentation on the frames for Seurat's last landscapes. A mildly skeptical commentator on opening day of the 1891 Indépendants exhibition observed, "M. Seurat feels it is advisable to paint the frames of his paintings with a violet, pointillist handling that, supposedly, should enhance the glowing tones on the canvas."[33] Camille Pissarro, who had been quite positive about Seurat's earlier frames, wrote to his son Lucien about the works at the Indépendants: "All his pictures are framed in chromatic colors and the ensemble gives the effect of an intense blue and violet stain; I find this disagreeable and discordant, it is not unlike the effect of plush."[34] Paul Signac was more enthusiastic, recording in his diary of 1894: "Saw again the paintings of Seurat in his mother's living room. The last seascapes of Crotoy and of [word missing, presumably Gravelines], in their colored frames, make marvels there. It is like soft and harmonious light glowing on these walls."[35] Emile Verhaeren offered the explanation that Seurat was also inspired to adopt dark frames by the Wagnerian stage practice, uncommon at the time, of darkening the theater to highlight the illumination of the stage.[36]

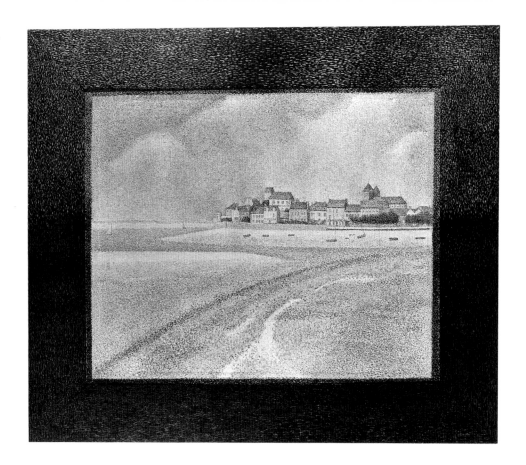

View of Le Crotoy from Upstream, 1889. Oil on canvas, with painted frame, 38 ¾ x 45 ⅛ inches (98.4 x 114.6 cm). The Detroit Institute of Arts. Bequest of Robert H. Tannahill.

More than thirty years later some of Seurat's landscapes apparently still carried their original frames, according to Roger Fry's comments about the 1926 exhibition at Lefèvre gallery in London: "Several of these landscapes [*Grand Fort Philippe, Petit Fort Philippe*, and one Port-en-Bessin canvas figured in that show] have fortunately retained their original frames, flat pieces of wood covered by the artist with his interminable spots of colour Seurat, therefore, set to work so to paint the frames as that, at each point, both colour and tone contrasts should be equal."[37] It is apparent that today's viewers of the Gravelines marines see them without the contrasting framing elements that Seurat regarded as integral to his works.

"Certain critics honor me by seeing poetry in what I do. But I just paint my method, without any other concern."[38] Seurat's famous remark has become synonymous with the artist's claim to a dispassionate attitude and his reliance on systematic procedures. Uttered more than a century ago to his colleague Charles Angrand, it has quite appropriately met with a hundred years of dissent. Nevertheless, the wide artistic continuum the remark establishes—from poetry to policy—suggests the gamut of ideas contributing to both the creation and interpretation of the final landscapes.

In 1886 when *A Sunday Afternoon on the Island of the Grande Jatte* made its debut at the last Impressionist exhibition, a cornerstone of Seurat's aesthetic was his application of recent theories of optics and perception. Relying upon his interpretation of treatises by aestheticians and scientists like Charles Blanc, Michel Chevreul, and Ogden Rood, and his examination of the paintings of Eugène Delacroix, Seurat formulated his approach to color theory by utilizing principles of contrast and *mélange optique*. According to optical mixture, individual dots of pigment on a canvas reflect colored light that blends in the eye, or upon the retina, of the viewer to produce the chromatic sensation. This method of "mixing" color was considered (after comparison with laboratory experiments and demonstrations) capable of producing more vibrant color effects than the traditional procedure of mixing pigments on the palette before applying them to the canvas.[39] The infamous pointillist, or dotted, application of pigment was merely the vehicle for achieving optical mixture. The other significant element of Seurat's aesthetic—even in 1886—was a preoccupation with harmonious line and geometric purity, evident in the order, formal arrangement, and sense of permanence which distinguished his work from that of the Impressionists. It was this effect of synthesis and enduring reality embodied in Seurat's works that appealed to the Symbolist poets and critics.[40]

Seurat's interest in linear direction and surface pattern continued to develop, taking on increasing importance and visibility in his work. The young painter expanded his studies to include analysis of the intrinsic expressive capacities of line and color, drawing upon the findings of Charles Blanc, David Sutter, and Humbert de Superville. In 1886 Seurat befriended the brilliant young aesthetician and scientist Charles Henry. Henry soon became part of the Neo-Impressionist coterie, and his research and laboratory experiments contributed to Seurat's conclusions on pictorial expression.[41] In formulating his own aesthetic theories, Seurat maintained that line, color, and value have emotive potential, independent of the forms they create.

The artist outlined his philosophy on harmony and his system of pictorial expression in the letter to Maurice Beaubourg of August 28, 1890 (page 51)[42] that has become the most significant document of Seurat's aesthetic and technique.[43] He assigned feelings of gaiety to lines above the horizontal, a dominance of warm hues, and a dominance of light tones. Calmness is connoted by horizontal lines, a balance of warm and cool hues, and a balance of light and dark tones. Sadness is suggested by downward directions and a dominance of cool hues and dark tones.

With its passages devoted to the communication of gaiety, calmness, and sadness, Seurat's 1890 statement of theory reflected the artist's more recent artistic concerns,

Seurat's letter to Maurice Beaubourg,
August 28, 1890.

Translation of Seurat's statement of theory,
from letter to Maurice Beaubourg.

Aesthetic

Art is Harmony.
Harmony is the analogy of opposites, the analogy of similar elements, of *tone*, of *color*, and of *line*, considered according to their dominants and under the influence of lighting, in gay, calm, or sad combinations.

The opposites are:

For tone, a more $\begin{Bmatrix} \text{luminous} \\ \text{light} \end{Bmatrix}$ against a darker one.

For color, the complementaries, $\begin{cases} \text{red-green} \\ \text{orange-blue} \quad \text{i.e., a certain red opposed to its complementary, etc.} \\ \text{yellow-violet} \end{cases}$

For line, those forming a right angle.

Gaiety of tone is the light dominant; of *color*, the warm dominant; of *line*, lines above the horizontal.

Calmness of tone is the equality of dark and light; of color, the equality of warm and cool; and of line, the horizontal.

Sadness of tone is the dark dominant; of color, the cool dominant; and of line, downward directions.

Technique

Granting the phenomena of the duration of the light impression on the retina, synthesis necessarily follows as a resultant. The means of expression is the optical mixture of tones, of colors (of the local color and the color of the illuminating light: sun, oil lamp, gas, etc.), that is to say, of the lights and their reactions (shadows), in accordance with the laws of *contrast*, gradation, and irradiation.

The frame is in a harmony opposed to that of the tones, colors, and lines of the picture.

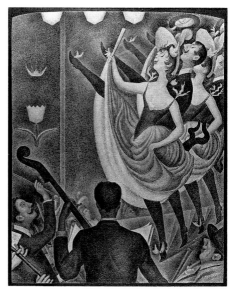

The Chahut, 1889–90. Oil on canvas, 67 ⅛ x 55 ¼ inches (169 x 139 cm). Rijksmuseum Kröller-Müller, Otterlo, The Netherlands.

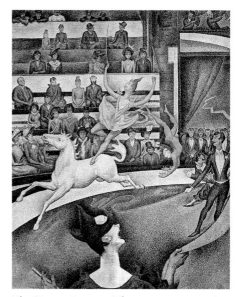

The Circus, 1890–91. Oil on canvas, 73 x 59 ⅛ inches (186 x 151.1 cm). Musée d'Orsay, Paris.

succeeding but not supplanting his emphasis on the transcription of color and light. His ideas on expression have received the most critical attention in analyses of Seurat's late works. *The Chahut* and *The Circus*, canvases painted just before and after the Gravelines seascapes, were recognized by Seurat's colleagues as showing his intent to correlate the inherent expressive qualities of color, value, and line. Upon seeing *The Chahut* exhibited at the Indépendants in spring 1890, Théo van Gogh remarked to his brother Vincent that Seurat was attempting "to express things by means of the direction of lines."[44] Writing about Seurat for the Belgian periodical *L'Art moderne*, his friend Georges Lecomte described the colors and lines that connote gaiety, concluding that "his *Le Chahut* is, in this sense, a first conclusive theoretical realization."[45] In the spring of 1890 Belgian Neo-Impressionist Henry van de Velde described *The Chahut*: "The intention, through a sustained direction of line, is to create a feeling of gaiety."[46]

How are we to perceive Seurat's seascapes in light of these theories? Did he apply his precepts of pictorial expression to his outdoor, nonfigural works? Henri Dorra[47] and Robert Goldwater[48] have pointed to indications of gaiety in certain Port-en-Bessin marines of 1888. Among Seurat's contemporaries, Félix Fénéon cited Seurat's awareness of a line's "abstract" value and described the concordance of dominant lines with dominant colors in the Crotoy landscapes,[49] though he stopped short of naming explicit emotions expressed in these paintings.

Charting the expressive currents of the Gravelines marines is less straightforward than interpreting the emotional quotients of Seurat's late figural works. Of all the Gravelines paintings, *The Channel at Gravelines, Evening* most readily lends itself to analysis in terms of Seurat's theory. Here the repetition of the dominant horizontal lines (and planes) clearly contributes to the painting's tranquil mood. The balance of light tones in the sky and sea with the darker tones of the anchors, post, boat, and wharf continues the calm note. The warm hues of red, yellow, orange, and rose seem roughly equivalent to the painting's disposition of dark blues and greens, though measuring exact parity is both difficult and unnecessary. In sum, the formal elements of the painting seem in harmony with the calm emotional effect of the scene.

The connection between theory and practice is less apparent in the other members of the series. In the *Channel of Gravelines, Petit Fort Philippe*, for example, the luminous tones of this afternoon scene make lightness dominant over darkness, which, according to Seurat's theory, would connote "gaiety of value." For the painting's color scheme, a predominantly blue sky competes with blue-green water and a rose and yellow sidewalk for what is at best a subtly colorful emotional standoff. If it could be determined with certainty that this chromatic content is evenly balanced, calmness would become the dominant element in terms of hue. In creating the surface pattern, Seurat found a plethora of lines above the horizontal, most obvious in the very dynamic curve of the wharf. Since another forceful axis exists in the staggered row of boats that repeats the flat line of the horizon, the emotional verdict for the linear elements hovers somewhere between the calm and gay registers. Thus, on balance of tone, hue, and line, Seurat's seascape assumes a position between calmness and gaiety—an ambiguous stance at best. This kind of emotional diagramming seems more likely to beg the issue than to offer a reliable analysis of the radiant scenes of Gravelines.

Seurat's contemporaries, alert to the evolution of his aesthetic and sensitive to the emotive elements within the figural works and some earlier seascapes, failed to

The Bridge and the Quays, Port-en-Bessin, 1888. Oil on canvas, 26 ⅜ x 33 ³/₁₆ inches (64.9 x 82.4 cm). The Minneapolis Institute of Arts. The William Hood Dunwoody Fund.

Seascape at Port-en-Bessin, Normandy, 1888. Oil on canvas, 25 ⅝ x 31 ⅞ inches (65.1 x 80.9 cm). National Gallery of Art, Washington, D.C. Gift of the W. Averell Harriman Foundation in memory of Marie N. Harriman.

detect efforts of this nature in the Gravelines canvases. Reviewing the spring show at the Indépendants, Adolphe Retté devoted a full paragraph to the "synthesis" of joy in *The Circus* but referred to the seascapes simply as "the calm blond marines, the tones of gentle nuance, with a sense of space, exquisite skies and a sort of solemn tranquility."[50] Similarly, Georges Lecomte recognized Seurat's expressive goals in *The Circus*, but called the marines nothing more specific than "resplendent."[51] Reporting on the 1891 exhibition of Les xx, Seurat's friend Emile Verhaeren described the meticulous arrangements designed to create a unity of emotion, using *The Chahut* as his example. Citing the Gravelines marines as "Seurat's triumph," he praised their delicate tones and harmonies, not an expressive bottom line.[52]

While Fénéon also recognized Seurat's orchestration of formal elements, he criticized the artist's highly stylized treatment of the clouds in the Crotoy landscapes, regretting that he fashioned their rounded forms into shapes resembling specific objects.[53] Indeed, Seurat's tendency to mold cloud formations to suit his design purposes was already evident in the seascapes of 1888. In *The Bridge and the Quays, Port-en-Bessin* and *Seascape at Port-en-Bessin, Normandy*, Seurat opted for stylized curvilinear clouds of an unrealistic stamp. These shapes were critical elements in the strong surface patterns that Seurat abstracted from his seaside subjects that year. By the summer of 1890, however, this decorative impulse had been suppressed, and the skies of Gravelines are populated only by thin wisps of naturalistic clouds. Perhaps this return to a more realistic treatment of the Gravelines clouds, no longer forced into distinct patterns, has its parallel in a broader fidelity to nature that precludes reshaping the formal elements of the scene to construct a specific emotional effect.

In the month following Seurat's death, Emile Verhaeren wrote a reminiscence of his friend that helps illuminate the role of marine paintings within Seurat's aesthetic. Recalling a visit to the artist's studio, Verhaeren reconstructed their conversation:

> *In winter he finished a large canvas, a canvas of research and if possible of conquest...*
> *—A painting with a thesis, I interrupted. But he didn't approve at all and continued ... Then, in summer, to wash his eyes of the days in the studio and to translate as exactly as possible the vivid sunlight, with all its nuances. An existence divided in two, by art itself.*[54]

While this reference to the artist's annual communion with sunlight is often cited in Seurat scholarship, the less familiar remarks about the "canvas of research" are also telling. It appears that even Seurat classified his paintings into two different categories, reserving the winter period for large projects to synthesize earlier studies and using the summer months for an escape from the studio environment and a return to the exercise of recording the behavior of color and the luminous effects of the sun. Although his landscapes sometimes became a testing ground for new techniques,[55] Seurat apparently considered the summer landscapes an opportunity to refresh his senses and powers of perception, without an obligation to pursue each aspect of his aesthetic agenda.

Seurat's treatment of the Gravelines landscapes suggests that during the summer of 1890 he distanced himself from "thesis" pictures, or prescribed arrangements of expressive elements, in favor of fidelity to the world of appearances. Evident in the Gravelines canvases is Seurat's commitment to transcribing the nuances of outdoor

light and his adherence to details of harbor topography. When he did choose to manipulate forms such as the boats or anchors, the added elements were not used to promote an expression of gaiety, calmness, or sadness. It is always possible that Seurat, who chose the sites of his seascapes with great care, could have selected views already offering lines, colors, and tones that illustrated his beliefs about their emotive properties. While this may have enhanced the appeal of certain Gravelines motifs, the scenes' overall expressive effects are much less insistent than those achieved by the arrangement of forms and colors in Seurat's figural works. Instead of becoming the motivating thesis of the Gravelines compositions, the communication of a specific emotive state is secondary to the artist's fidelity to his site and senses.

More appropriate to the Gravelines landscapes are the eloquently simple opening phrases of Seurat's 1890 statement, often overlooked in favor of its passages dealing with expressive effects. Seurat defined art in terms of harmony. Further, he defined harmony in terms of the analogy, or rapport, of similar and contrasting formal elements. Thus a visual, pictorial harmony of color, line, and tone can exist for its own sake, independent of a specific expressive message. In his detailed analysis of Seurat's methods, William Homer distinguished between the handling of formal elements to "insure the expression of certain specific emotional states *or* create pictorial harmony."[56] This general interpretation of Seurat's description of harmony seems pertinent to the four Gravelines scenes, as Seurat delicately calibrated his nautical equations, matching similar elements or balancing contrasting ones to create harmonious overall effects. The Gravelines seascapes should be read less as recipes for a certain emotional flavor than as four configurations of pictorial grace.

As carefully crafted essays in harmony, the Gravelines canvases alone could ably refute Seurat's disavowal of poetry. Just as their expressive content cannot be subsumed under one formulaic approach, neither can their essence be attributed to a list of methods. Viewing the seascapes from Gravelines, we might be more inclined to take the side of Symbolist poet Theodor de Wyzewa, who concluded that the marine paintings "owe more to the soul of Seurat than to his methods and theories."[57]

The Gravelines Ensemble

The Gravelines marines, the work of a thirty-year-old man with a reasonable prospect of a lengthy career and an established record of rapid aesthetic progression, cannot honestly be presented as his definitive artistic statement. They are, nevertheless, the last statements of a remarkably mature painter, sufficiently confident of his own methods to commit them to print and sufficiently engaged by the seaside to recast its imagery in one more series of canvases. For yet another summer interval, the eye that cast an ironic glance at the activities of modern urban life shifted its gaze to unpeopled coastal villages, where the tempo of contemporary life was stilled by deftly orchestrated pattern and limpid atmosphere.

An artist who had already transcribed overcast skies and vibrant sunshine, on his fifth campaign by the sea Georges Seurat was still drawn to the chromatic chemistry of light and atmosphere. Through the vistas of the Gravelines quartet, Seurat courted changing sunlight, deepening shadows, and elusive reflections, capturing them in the gently varied tints of Channel atmosphere. Poet Emile Verhaeren, arguably the most eloquent champion of Seurat and his art, perceived the subtle nuances of Gravelines light and color: "For this precision of harmonies, this special and clear sonority, is miraculously achieved in the *Forts . . .* of M. Seurat." And in the simplest, and best, description, he concluded, "It is air and light, even and tranquil, fixed in frames."[58]

Also fixed in frames is the taut network of lines and shapes that Seurat distilled from the Gravelines landscape. The seaport offered the painter straight jetties, sweeping embankments, vistas purged of vegetation. The painter accepted—and responded with highly developed powers of perception and design. Even without the clues provided by the preparatory drawings and sketches, the viewer can sense the meticulous efforts to achieve that "analogy of opposites, the analogy of similar elements" basic to Seurat's harmonies. Pairing a scrupulous fidelity to nature with his predilection for ordered surface pattern, Seurat created pictures that elide the line where observation stops and pictorial invention begins.

The exquisite synthesis typical of the Gravelines pictures moved critic Roger Fry to see in Seurat's paintings a "passion for reducing the results of sensation to abstract statements."[59] Filtering the raw visual data of Gravelines, the artist dispensed with extraneous details and tailored picturesque images that also ask to be read as configurations of lines, colors, and shapes. Specifically referring to the canvases from Gravelines, another critic concluded, "One more time, Seurat is driven to the frontiers of this unknown realm, where he doesn't want to enter, but toward which the logic of his evolution irresistibly draws him."[60] Indeed, Seurat's theories as well as his paintings point to a rendez-vous with abstraction. Yet in the marines of 1890 Seurat shows himself to be an artist still passionately committed to recording what he sees. And while he is also the master architect of formal elements, attuned to surface design by instinct and training, his ground rules still call for images tied to the world of representation. As the views of Gravelines slip back and forth between pattern and perception, Seurat's last landscapes shimmer on the edge of abstraction.

The essence of the Gravelines paintings seems to lie in just such elusive territories. In spirit, they combine a passion for intellectual rigor with some gentler sensibility,

difficult to define. In formal terms, they offer a taut linear framework to support the lightest of chromatic burdens. In a much larger sense, then, Seurat brings his analogy of opposites to an ineffable harmony in his images of the sea.

The artist Charles Angrand, in his memories of Seurat and the sea, reflected that his friend "was the first to render the spirit the sea inspires on a calm day."[61] While Seurat's chronological priority might be debatable, his expressive priority is not. The Gravelines ensemble is the final chapter of an artistic legacy that achieves a tranquility bordering on the ideal, as Seurat's views of the sea consistently reveal a harmony of the aesthetic and physical worlds. And while Seurat's marines are sometimes characterized as melancholy, it is the sense of calm, with only an occasional wistful interlude, that prevails in the radiant world of Gravelines. These late coastscapes seem to abide by the text of a Turkish painting manual that Seurat is known to have copied some five years before. Counseling artists to record the tranquil moments instead of the climactic ones, the static rather than the active poses, the Turkish painter advised that "everything in your work should breathe the calm and peace of the soul."[62] In Seurat's hands, those words are transformed into the poetic vision of the artist's last landscapes.

Notes

All translations are those of the author unless otherwise cited.

1. Letter from Charles Angrand to Henri Edmond Cross, quoted in Robert Rey, "Seurat," in *La renaissance du sentiment classique dans la peinture française à la fin du XIXᵉ siècle* (Paris, 1931), p. 95.

2. I am indebted to Pierre Angrand for the dating of this correspondence. In a letter of June 4, 1990, to William Butler, Angrand brackets the letter's date between 1906 and 1909, with the conclusion that it was probably written during the summer of 1908.

3. *A Sunday Afternoon on the Island of the Grande Jatte*, 1884–86 (The Art Institute of Chicago); *The Parade*, 1887–88 (The Metropolitan Museum of Art); *The Chahut*, 1889–90 (Rijksmuseum Kröller-Müller); *The Circus*, 1890–91 (Musée d'Orsay).

4. Emile Verhaeren, "Georges Seurat," *La Société Nouvelle* 7 (April 1891), p. 433, as quoted in John House, *Post-Impressionism: Cross-Currents in European Painting* (London, 1980), p. 135.

5. Seurat's military service lasted from August 22 to September 18. Richard Thomson, *Seurat* (Oxford, and Salem, NH, 1985), pp. 130, 231, fn. 33, citing Henri Perruchot, *La Vie de Seurat* (Paris, 1966), p. 108.

6. This locale may have been recommended by Seurat's colleague Paul Signac, who had summered there in the early 1880s. Thomson, *Seurat*, p. 168; and Jean Sutter, ed., *The Neo-Impressionists* (Neuchâtel, London, and Greenwich, CT, 1970), p. 47.

7. Karl Baedeker, *Northern France from Belgium and the English Channel to the Loire, Excluding Paris and Its Environs, Handbook for Travellers* (Leipzig, 1894), p. 5.

8. "Je vais dans le Nord environs de Calais?" Seurat to Fénéon, June 24, 1890. For facsimile of letter, see César de Hauke, *Seurat et son oeuvre* I (Paris, 1961), p. xxiii.

9. There appears to be no documentation that records the details of Seurat's sojourn at Gravelines. According to de Hauke, *Seurat* I, p. xxvi, Seurat resided at the rue de l'Esturgeon. In a letter of June 1990 to Ellen Lee, Raymond Delahaye, a historian affiliated with the city of Gravelines, reported that this street was destroyed during World War II and was not reconstructed. He has confirmed, however, that it was located one block from the channel and the shore. He proposes that Seurat resided at the Hôtel du Phare.

10. Paul Smith's study of the Honfleur paintings concluded that this body of work also encompassed nearly a full range of daylight conditions. Paul Smith, "Seurat and the Port of Honfleur," *The Burlington Magazine* 126, no. 978 (September 1984), p. 569, fn. 17.

11. The seven paintings dating to Seurat's stay in Honfleur were handled in this manner. Seurat departed from Honfleur in August 1886 with several canvases in various stages of completion, as stated in a letter from Seurat to Signac, August 1886, quoted in Henri Dorra and John Rewald, *Seurat—L'oeuvre peint, biographie et catalogue critique* (Paris, 1959), p. lii (in French) and in Thomson, *Seurat*, pp. 159, 163 (in English).

12. See de Hauke, *Seurat* I, Appendix, pp. 226–27 for facsimiles of these exhibition catalogues.

13. Many details on the history and geography of Gravelines are available through a publication of the Ministry of Culture, *Gravelines et son patrimoine* (Dunkirk, 1983).

14. Robert L. Herbert, *Impressionism—Art, Leisure, and Parisian Society* (New Haven and London, 1988), p. 306.

15. The flags indicate that the tide has entered its rising phase. I am grateful to Raymond Delahaye for clarifying the information provided by the Gravelines signal mast.

16. As Niels Luning Prak has indicated, a triangular corner configuration is created in *The Chahut* by the bass player and his instrument and in *The Circus* by the curtain pulled by the clown. "Seurat's Surface Pattern and Subject Matter," *The Art Bulletin* 53, no. 3 (September 1971), p. 372. A similar treatment can also be seen in the skirt of *Young Woman Powdering Herself*, 1889–90 (Courtauld Institute Galleries).

17. David Sutter, "Les Phenomènes de la vision," *L'Art* 20 (1880), p. 76, cited in Prak, ibid., p. 372.

18. The current residents of the home report that the house was built in 1883 and is one of the few structures along the channel that was not destroyed during World War II. Beneath the dark layers of dirt now caked upon its facade is an occasional patch of the house's original pale yellow brick.

19. Emile Verhaeren, "Chronique Artistique, Les XX," *La Société Nouvelle* 7 (February 1891), p. 249.

20. William Innes Homer, *Seurat and the Science of Painting* (Cambridge, MA, 1964), p. 76. See also Sutter, ed., *The Neo-Impressionists*, p. 34.

21. For a discussion of the development of the light and dark borders, and Seurat's application of dark borders on earlier works, see Dorra and Rewald, *Seurat*, pp. xcvi, cii, ciii.

22. In 1886, for *Entry of the Port of Honfleur* (The Barnes Foundation), Seurat had chosen a similar schema, showing the passage of boats out to sea flanked on either side by the harbor's wharves or jetties.

23. During the Napoleonic wars this area of the channel port adjoined the "City of Smugglers," a center for French and English smuggling. At mid-century it was a shipyard, principally for large and small fishing boats. For a history of the basin, see Ministry of Culture, *Gravelines et son patrimoine*, pp. 177–88.

24. Period photographs indicate that this embankment, now cement, was formerly covered with grass.

25. See Robert L. Herbert, "Seurat's Theories," in Sutter, ed., *The Neo-Impressionists*, p. 29, for a description of the law of irradiation and its relation to the basic principles of contrast operative in Neo-Impressionism.

26. The suggestion in Prak, "Seurat's Surface Pattern and Subject Matter," p. 372, that Seurat reduced the width of the shadow to balance the composition is incorrect, as the photograph of the site illustrates.

27. John Russell, *Seurat* (New York, 1985), p. 252.

28. Jean Hélion, "Seurat as a Predecessor," *The Burlington Magazine* 69, no. 400 (July 1936), p. 9.

29. The informative comparison of Seurat's *Bec du Hoc* (The Tate Gallery, London) with Hokusai's *Boat Fighting with Wave* (National Museum, Tokyo) was first presented in Henri Dorra and Sheila C. Askin, "Seurat's Japonisme," *Gazette des Beaux-Arts* 73, pér. 6 (February 1969), pp. 84 (ill.), 85.

30. Françoise Cachin, "Les Néo-Impressionnistes et Le Japonisme, 1885–1893," *Japonisme in Art* (Tokyo, 1980), p. 227.

31. It appears that the linear aspect of the framing program that Seurat cited (and described with small schematic drawings) was applied to the figural pieces rather than to the seascapes. Again, the painted borders provide the cue, as the perimeter that surrounds *The Chahut* has an arched treatment at the top that corresponds to the first of Seurat's small drawings, the one apparently reserved for lines above the horizontal. Since *The Chahut* is in fact dominated by lines projecting up from the horizontal, Seurat's subtle alteration of the standard straight border does seem to apply to his specifications for frames. Further, this shaped border also appears at the top of *Young Woman Powdering Herself*, another composition cited for its dominance of lines above the horizontal. The only exception to this procedure in the late figural paintings occurs in *The Circus*, where Seurat may have resisted the shaped top because of the preponderance of horizontal lines found at the top of this composition.

32. For a detail of this frame, made by David Miller in the Indianapolis Museum of Art Conservation Laboratory, see Ellen W. Lee, *The Aura of Neo-Impressionism: The W. J. Holliday Collection* (Indianapolis, 1983), p. 31, fig. 4.

33. P. Bluysen, "Au Jour le jour, L'Exposition des Indépendants," *La République Française* (March 20, 1891).

34. John Rewald, ed., *Camille Pissarro: Letters to His Son Lucien* (New York, 1943), p. 156.

35. John Rewald, ed., "Excerpts from the Unpublished Diary of Paul Signac, I (1894–1895)," *Gazette des Beaux-Arts* 36, pér. 6 (July 1949), p. 170.

36. Verhaeren, "Georges Seurat," p. 433, as translated and explained in Norma Broude, ed., *Seurat in Perspective* (Englewood Cliffs, NJ, 1978), pp. 27–28.

37. Roger Fry, "Seurat," *Transformations—Critical and Speculative Essays on Art* (London, 1926), pp. 195–96.

38. Comment to Angrand, quoted in Rey, *La renaissance du sentiment classique*, p. 95.

39. See Robert Herbert, "Seurat's Theories," in Sutter, ed., *The Neo-Impressionists*, pp. 23–42; and Lee, *The Aura of Neo-Impressionism*, pp. 15–21, for additional information on these theories and their applications.

40. For more information on Seurat's relationship to the Symbolist writers, see Sarah Faunce, "Seurat and 'the Soul of Things'," in *Belgian Art: 1880–1914* (Brooklyn, 1980) pp. 41–56.

41. For additional information on Henry's studies, see Jonathan Crary, "Seurat's Modernity," on p. 63 of this catalogue.

42. Seurat to Maurice Beaubourg, August 28, 1890. While Seurat's letter was dated, he did not indicate his location. Since the exact day of his return to Paris has not been established, it can only be surmised that the artist was still on the coast. However, the fact that this information was transmitted by letter does not in itself confirm that Seurat was outside of Paris, since the previous June, before he left Paris, Seurat's corrections about various aspects of his aesthetic were communicated to Félix Fénéon in letter form.

43. Other solid explanations of Seurat's Neo-Impressionist aesthetic exist, but none bears the same timeliness to the Gravelines works. Seurat's friend, the critic Félix Fénéon, published a lucid description of the technique involved in *A Sunday Afternoon on the Island of the Grande Jatte*. The text ("Les Impressionnistes en 1886," as excerpted in John Rewald, *Post-Impressionism: From van Gogh to Gauguin*, 3d ed. [New York, 1978], pp. 88–89) was based on thorough conversations with Seurat and was received by the Neo-Impressionist painters as an accurate account, though it only reflected Seurat's approach as of 1886. In the spring of 1890 Seurat produced a statement of his theories that appeared at the end of a short biography published by his friend Jules Christophe in *Les Hommes d'aujourd'hui* 8, no. 368 (1890), but there was some confusion in the printing and Seurat considered it flawed.

44. Letter from Théo van Gogh to Vincent van Gogh, March 19, 1890, *Complete Letters of Vincent van Gogh* III (London, 1958), T.29, p. 565, as quoted in Thomson, *Seurat*, p. 206.

45. Georges Lecomte, "Société des Artistes Indépendants," *L'Art moderne* (March 30, 1890), pp. 100–1, as quoted in Homer, *Seurat and the Science of Painting*, p. 185.

46. Henry van de Velde, "Notes sur l'art," *La Wallonie* (May 1890), p. 123, as quoted in Joan U. Halperin, *Félix Fénéon, Aesthete and Anarchist in Fin-de-Siècle Paris* (New Haven and London, 1988), p. 128.

47. Dorra and Rewald, *Seurat*, p. xciv.

48. Robert J. Goldwater, "Some Aspects of the Development of Seurat's Style," *The Art Bulletin* 23, no. 2 (June 1941), p. 130.

49. Félix Fénéon, "5e. Exposition de la Société des Artistes Indépendants," *La Vogue* (September 1889), in Fénéon, *Oeuvres plus que complètes* I, Joan U. Halperin, ed. (Geneva, 1970), pp. 164–65, as quoted in Homer, *Seurat and the Science of Painting*, p. 184.

50. Adolphe Retté, "Septième Exposition des Artistes Indépendants, Notes Cursives," *L'Ermitage* (April 1891), p. 294.

51. Georges Lecomte, "Le Salon des Indépendants," *L'Art dans les deux mondes* (March 28, 1891), p. 295.

52. Verhaeren, "Chronique Artistique, Les XX," pp. 249, 251.

53. Fénéon, *Oeuvres plus que complètes* I, pp. 164–65, as cited in Thomson, *Seurat*, p. 169.

54. Verhaeren, "Georges Seurat," p. 433, reprinted (with slight variations, as noted by Robert Herbert) in Verhaeren, *Sensations* (Paris, 1927), p. 199. For another English translation of the full article, see Broude, ed., *Seurat in Perspective*, pp. 25–30.

55. Thomson, *Seurat*, p. 173.

56. Homer, *Seurat and the Science of Painting*, p. 239, emphasis added. See also the comments on p. 184.

57. Theodor de Wyzewa, "Georges Seurat," *L'Art dans les deux mondes* (April 18, 1891), pp. 263–64.

58. Verhaeren, "Chronique Artistique, Les XX," p. 249.

59. Fry, "Seurat," *Transformations*, p. 188.

60. Perruchot, *La Vie de Seurat*, p. 156.

61. Charles Angrand to Henri Edmond Cross, ca. 1908, cited in Rey, *La renaissance du sentiment classique*, p. 95.

62. Seurat's copy of the text is in the Signac Archives. Françoise Cachin has identified its source as a manuscript by Vehbi Mohamed Zunbul-Zadé. Excerpts from it, including the one cited above, are quoted in Robert L. Herbert, "Seurat in Chicago and New York," *The Burlington Magazine* 100, no. 662 (May 1958), p. 151.

Seurat's
Modernity

Jonathan Crary

As we look at Seurat's supremely self-assured Gravelines landscapes, it is astonishing to remember they are among the very late works of an artist, with barely six months to live, who was then only thirty years old. Within the wistful annals of artists who died young, the incalculable loss of the unrealized work and thought of a mature Seurat looms large. We only have to imagine Picasso's career ending in 1912, Monet's in 1871, Cézanne's in 1870 to sense the immense potential that was eradicated by a virulent throat infection. But the very fact of Seurat's youth can help to put his career in a revealing historical perspective. Consider that Seurat would have been only in his forties and very early fifties in the years between 1900 and 1912, unquestionably the most revolutionary period in the history of modern art, a time when Kandinsky, Matisse, Duchamp, Kupka, Picasso, and Braque (to name only a few) were radically transforming the conditions of aesthetic experience. There is no possible way to guess what extraordinary contributions Seurat might have made to the development of modernism—not only how he would have responded to the work of younger artists, but also how he might have led them, challenged them. Everything we know about Seurat suggests that his work would never have congealed into the repetition of a youthful style but that he would have been perpetually open and responsive to the dynamic and rapidly changing events in culture, technology, and science in the early twentieth century.

Understanding Seurat requires us to see him as an artist ahead of his time, whose intellectual concerns are, in fundamental ways, more akin to certain twentieth-century artists than to his immediate contemporaries in the late 1880s. That is, Seurat was a figure deeply interested in the modernization and rationalization of perception and aesthetic response, in the same way we could say this of, for example, the Russian filmmaker Sergei Eisenstein, the Bauhaus designer László Moholy-Nagy, or even the composer Arnold Schönberg. So although the subject matter of Seurat's work, including the Gravelines landscapes, bespeaks its historical proximity to Impressionism and other nineteenth-century developments, on a deeper level these images were generated by a very different set of forces. Seurat effectively inaugurates a new technocratic paradigm of the artist (radically unlike the escapist model of van Gogh or Gauguin). What is new is his conscious development of an antirepresentational formal thinking immanent to an emerging modern society based on abstract value and on modes of mechanical mass reproduction.

Although much has been written about Seurat's relation to contemporary science, many misleading notions persist about the place of scientific thought in his work. One problem is that we are often led to think in terms of relatively secure and stable categories—of artists making something called art and scientists doing something called science in some other area of activity. Seurat is often seen as someone who in various ways "used" or borrowed scientific ideas or theories in order to make his paintings, but this tends to obscure the ways in which the fundamental aims of art and science often overlap and intermingle. The 1880s were a time when thinkers and researchers from a wide variety of fields were probing the structure of perception, the relation between mind and sensation, and how the external world could be most usefully represented. These included psychologists, philosophers, poets, physiologists, philologists, and painters. It was a period when the earlier certainties of positivism and realism about the reliability of perception and of realist forms of representation were being profoundly questioned. To better situate Seurat, we can note that he was born the same year, 1859, as the philosophers Henri Bergson, John Dewey, and Edmund Husserl—that is, within a generation of thinkers for whom the analysis and reconstruction of perceptual and cognitive knowledge was a crucial cultural problem.

One area on which debates about perception centered was the problem of sensation. The physicist Ernst Mach held an influential belief that human vision did not directly see the world and its objects but perceived isolated units of sensation that the brain then recomposed into a comprehensible world. We could never be sure of the actual nature of the world, he asserted; all we could really know with certainty was the psychological experience of our own sensations. Mach said that "complexes of sensation" are the primary elements of experience and that our ideas of matter and objects are mental constructions, fictions built out of the raw material of our sensations. Henri Bergson, from a very different perspective, also challenged the way representational conventions led us to conceive of the world as full of separate and discrete objects and forms. This was a useful shorthand at times, but it concealed what he believed is the underlying continuity and interpenetration of all matter. Bergson criticized the "delimiting and fixing" of reality into stable images: "All division of matter into independent bodies with absolutely determined outlines is an artificial division."

The world of Seurat's art is closely related on an intellectual level to what Mach, Bergson, and others were outlining. Whether or not Seurat read or was familiar with these other thinkers is not the point. What matters is that his work is one crucial part of a pervasive epistemological shift in the late nineteenth century. Seurat's Neo-Impressionism is not simply an artistic style but is equally a philosophical position about the way in which knowledge is built up and the way in which objective reality can be most usefully represented.

Seurat's technique, as it took shape in the mid-1880s, was based on his unifying pointillist surface and his decomposition of local color. Rather than an immediate transcription of the world, Seurat's dots are a dense accumulation of abstract signs that only indirectly represent it. Color for Seurat is not a property of objects but a construction out of elements that individually do not refer to anything other than themselves. The world is not something passively received by the senses; it has to be rebuilt and synthesized artificially. This annihilation of local color in Neo-Impressionism stands as one of the most important foundations for a more thorough escape from representation and for the emergence of abstraction, for instance, in the work of Matisse and Kandinsky.

One of the key ways we experience the abstraction of color in a work by Seurat is through our own physical movement—back and forth from a position close enough so that the individual points of color are visible and the artificial and constructed nature of the surface is overwhelmingly evident, to a more distant point at which the surface coalesces into a unified and shimmering image of a recognizable world. Thus there is a deliberate disjunction between subjective appearance and the signs employed to create that appearance. One might claim this is also how we experience older art, say a Rembrandt or Velázquez, but Seurat showed a conscious and systematic awareness of the part played by the spectator in the making of the work of art. We know that he thought carefully about the different effects of his work from specific distances and thus made his art for a mobile spectator who would occupy multiple viewpoints. Seurat's revolutionary use of optical mixture (as opposed to conventional pigment mixture) is perhaps most important for the way it transforms the role of the spectator from a passive one to an active one. For example, in *The Parade* when Seurat systematically covers an area of his painting with regularized touches of yellow, orange, and blue, he is relying on the

physiological capacities of the spectator's retina to synthesize these distinct sensations into the appearance of a glowing atmospheric haze. According to several critics, Seurat thus not only mechanizes his own application of paint into a repetitive sequence of impersonal touches, but also "industrializes" the viewer into the production process.

Seurat's insistence on the physical movement and operation of the observer's body is confirmed by his interest in the work of the somewhat eccentric scientist Charles Henry. There are in fact some specific connections between Henry's often obscure mathematical ideas and structural elements of Seurat's pictures, as Seurat's famous letter to Maurice Beaubourg in August 1890 strongly suggests. But what is more important are the ways in which Henry was representative of a wide and powerful intellectual trend in France and elsewhere in which the study of perception, sensation, and cognition were producing techniques for rationalizing human perception and for making sensory experience something that could be measured and represented quantitatively.

Henry's work, especially in the late 1880s and early 1890s, was saturated with other studies in scientific psychology going on at the time. One major consequence of this research was that it provided knowledge for controlling and predicting human behavior. It allowed researchers to establish notions of the normal and the abnormal in human perception, and Henry in fact conducted some of his experiments on patients in the famed mental hospital of Salpêtrière. Much of his work on vision had to do with different forms of visual response: problems of attentiveness, reaction times, the intensity of sensations, how visual forms and colors affected someone and under what conditions. The part of his work that apparently interested Seurat was a search for general laws of aesthetic experience, an attempt to determine empirically what kind of contrasts, rhythms, and relationships produce pleasing or displeasing experiences. In its calculated and quantitative approach to human response, it was ultimately a kind of emotional engineering. (Already in the 1870s the legendary Golden Section had been demystified by perceptual tests supposedly proving statistically that it was simply a rectangle that induced an agreeable mood in viewers.) The aim of Henry's aesthetics, then, was not to establish rules for making a masterpiece but rather to determine the *physiological* effect of specific forms on a human subject.

All of Henry's work on vision is based on the notion that every sensation is accompanied by a motor phenomenon, in other words by a nervous and muscular reaction. One of his ideas most relevant to Seurat's work was that visual forms that seem to move upward and to the right produce an intensified and expansive nervous response which he called "dynamogenic" (a word already in widespread use), while forms that appear to move downward and to the left produce an "inhibitory" motor response. Again this was knowledge that provided the basis for attempts at controlling and manipulating the responses of an observer. Henry, for instance, was always concerned with the application of his ideas to increasing efficiency in human labor, and he wrote extensively about human energy and fatigue with the aim of preventing inattentiveness in the workplace.

Seurat's paintings should not be seen in any sense as an illustration of Henry's or anyone else's theories. They are decisively the articulation of his own ideas. But nonetheless it is clear that Seurat was comfortable working within a discourse and a

set of visual techniques related to empirical studies of the body, the nervous system, perception, and stimulus-response mechanisms. Even if one of Seurat's goals was the elusive pursuit of what he termed "harmony," his means to achieve it incarnate a very different paradigm from the notion of a pure perception severed from the merely physical or empirical vision, which much of visual modernism took as its foundations. Seurat's practice and his deployment of a mobile, productive spectator are resolutely subversive of any transcendental pretensions. He painted for an observer who was unequivocally situated in a physical and social world—the human experience of art was governed by the same laws and forces as physiology, physics, and chemistry. There was no separate kind of autonomous aesthetic perception as French Symbolist theorists or neo-Kantian art criticism insisted. And even if we know little for certain about Seurat's political or social beliefs, he was working at a historical moment when the forces of technological innovation and empirical scientific work would have seemed compatible with progressive political ideas. It may well be that Seurat's practice is ultimately an attempt at an impossible reconciliation—a belief that the utopian aspirations of art could coincide with scientific and industrial models, with an ideology of scientific and material progress.

Seurat was the painter of a wholly modernized vision, and not simply because he chose subject matter from contemporary urban life. The idea that Seurat is a conservative painter of stable, classical forms is highly paradoxical, because his work is so deeply about a dynamic and mobile apprehension of the world. Much of his art is an assertion of the actual instability and transience of a perceived world, in the same way that his Neo-Impressionist technique presupposes an ambulatory and depositioned observer. The last years of Seurat's life coincide with the introduction of more and more experiences of movement into social life, and consequently into consciousness and perception. The late 1880s and early 1890s, for example, saw the appearance of some of the early forms of cinema, like Edison's Kinetiscope or Emile Reynaud's Théâtre Optique, and it is hard to believe that Seurat, had he lived, would not have taken a great interest in the aesthetic possibilities of these techniques. One of the crucial problems for visual modernism was how to represent phenomena of becoming, and processes of change, whether temporal or qualitative. Philosophers like Bergson and Nietzsche had staked out such problems in the 1880s: they opposed representing the world as static, permanent, or stable and sought alternate descriptive strategies.

Seurat's marines, as much as any part of his work, tend to reinforce the idea of his predilection for classical and harmonious compositions: they seem a far cry from the action-filled scenes of Parisian nightlife like *The Chahut* or *The Circus* or of the gritty industrial suburbs of Paris. But in fundamental ways these paintings are a meditation on a world of ceaseless change and movement. The four Gravelines works are images of a primal flux, of impermanence and drift, in which the apparent stability and discrete identity of objects is but a precarious and provisional construction amid a shifting world of becoming, of change. For Seurat, the harbor or port is a site where forms and categories blur and overlap, where nature and culture interfuse, where the boundaries between air, sea, and earth become indistinct. He uses the space of the harbor to set up a dialogue between motion and relative rest, a rhythm of movement and apparent stasis. Even when a ship is at anchor it is caught up in a slow undulating or tidal motion, just as our own reception of the painting is filtered through the ceaseless pulsings and modifications of our physiological apparatus.

In *The Channel of Gravelines, Petit Fort Philippe* the mooring in the center foreground seems to claim a solid rootedness, as a kind of visual anchor. But just as it is not securing any ship, so it does not stabilize our vision. In this atomized world of light and atmosphere there is no longer any kind of central point that grounds us. Instead the bollard is lodged amid a set of powerful centrifugal forces which radiate, spiraling out in the stunning curve and thrust of the harbor embankment that visually pulls the waterway and the opposite shore into a converging vanishing point at the far right of the painting. There is an optical velocity, which pulls us to one side, that is at odds with the apparent tranquility of the scene. We find a suggestion of a pinwheeling effect not unlike what takes place more dramatically in Signac's famous *Portrait of M. Félix Fénéon in 1890* (David Rockefeller Collection, New York), done later the same year. Related effects can be seen in *The Channel at Gravelines, Evening*, where the anchors silhouetted against the sky and water cannot prevent the solidity of the world from dissolving into a dazzling cascade of chromatic reverberations, of interpenetrating forms and substance. The anchors, disintegrating into motes of color, along with indications of a wind and the drift of sailboats, also become part of another abstract visual language, following Charles Henry's search for dynamogenic effects in their explicit lure of our eyes to the right and upward. Despite the preindustrial contours of Gravelines, it is important to remember that Seurat's Neo-Impressionism was a crucial precedent for the turbulent and motion-filled world of the Italian Futurists; even here he provided them with a universe already latent with lines of force and vibrating fields of energy.

In other ways the Gravelines series suggests the work of an artist only thirteen years younger than Seurat who also painted along the same coastline less than a hundred miles to the north—the Dutch painter Piet Mondrian. He was another artist who, for a time, was powerfully affected by the possibilities of Neo-Impressionist divisionism and was also attracted to the elemental horizontality of seascapes and the coast. But with a sublime reductiveness Mondrian produced increasingly austere images of the coastline, with piers and lighthouses, to finally arrive at his own logic of visual form, of the vertical and the horizontal (which Seurat, in his own way, also used), and of unmodulated primary color. But Mondrian's transcendental vocabulary of form was radically unlike Seurat's. For Seurat painting never had any absolute meaning but was always rooted in the pragmatic activity of the artist and his embeddedness in a rapidly changing social world. Seurat sought a finely wrought clarity in both his method and in the final products of his work. But his art was always part of a heterogeneous process of testing and learning informed by empirical knowledge and practices of many kinds, from the emerging mass culture of everyday urban life to difficult scientific hypotheses and procedures; it was an art immediately adjacent to contemporary problems of language, labor, technology, economics, and spectacle. This many-sided "impurity" was part of the multiple legacy Seurat bequeathed to the twentieth century.

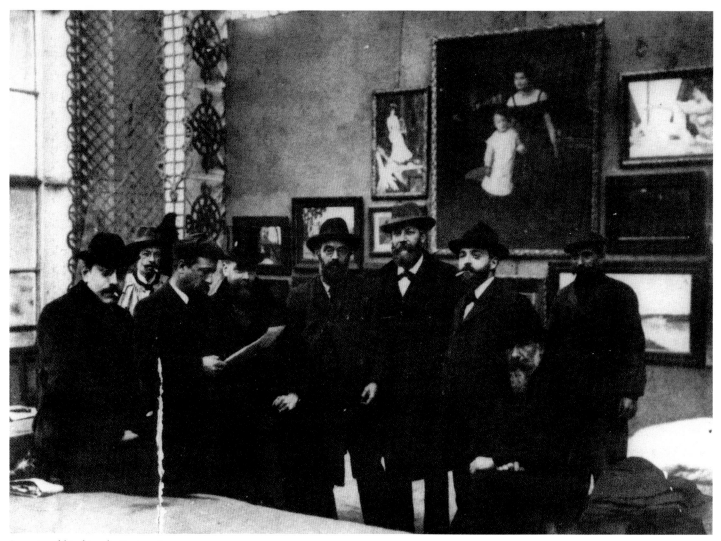

Seurat and his friends, Paris, 1890.
From left to right: Albert Dubois-Pillet,
Théo van Rysselberghe, Paul Signac,
Maximilien Luce, Seurat, Charles Angrand,
Henri Edmond Cross.

Biography

William M. Butler

Born December 2, 1859, in Paris, Georges-Pierre Seurat was the third child of Chrysostome-Antoine, a retired judicial official, and Ernestine, a quiet and industrious housewife. M. Seurat, an alternately proper and eccentric man, chose to live apart from the family in a nearby suburb. Much of Seurat's sense of propriety and preference for isolation may be traced to his father's example. Mme. Seurat was particularly attached to her youngest child, an affection Seurat seems to have returned. Even after leaving home, he dined each night with his mother.

Seurat began his brief but extraordinary artistic career at fifteen in a municipal drawing school, where he copied plaster casts of antique statuary and drew from the model. An unexceptional student, he advanced through diligence to the Ecole des Beaux-Arts in 1878 to study with the Ingres disciple Henri Lehmann. During his one-year attendance, he refined his draftsmanship and was taught to develop a painting by means of preparatory drawings and oil sketches. He also acquired an appreciation for classical order, evinced by his early enthusiasm for J.-A.-D. Ingres (1780–1867), the classically oriented painter Pierre Puvis de Chavannes (1824–98), and the Renaissance artist Piero della Francesca (ca. 1410/20–92).

While an art student Seurat read Charles Blanc's *Grammar of the Arts of Design* (1867), which synthesized several art theories and art-related scientific studies into a set of absolute rules for making art. Blanc gathered the findings of Eugène Delacroix (1799–1863) and chemist Michel Chevreul on color and suggested that a painter could learn color "like music." Here Seurat was first exposed to color concepts, such as simultaneous contrast, that would occupy him throughout his career.

Blanc's writings and the effusion of color and new methods Seurat encountered at the fourth Impressionist exhibition (1879) were probably the young artist's main sources of inspiration after his departure from the Ecole des Beaux-Arts. In November 1880, after completing his compulsory military service in Brest, on the Brittany coast, he returned to Paris and rented a studio. A regular allowance from his parents let him devote full attention to his art career.

Working with black conté crayon and a rough-textured paper, Seurat taught himself to make the velvety tonal drawings that Paul Signac, his Neo-Impressionist colleague, would later call "the most beautiful painter's drawings there are." In them Seurat tried to follow Blanc's suggestion that drawings be constructed according to principles of light and shadow, rather than linearly as the Ingres-centered academy taught. Seurat's goal was to create in the drawing the illusion of a light source that revealed essentials of form. His study of Rembrandt's graphic work also helped him in this endeavor. The drawings' major subjects were industrial suburbs and peasantry, reminiscent of Daumier and Millet.

The paintings from these early years, in which Seurat tested his understanding of color principles, are primarily landscape sketches inspired by the Barbizon School. Not until 1884 did Seurat complete his first major painting, *Bathing, Asnières*. Although Seurat had successfully entered a conté drawing of his friend Edmond Aman-Jean in the 1883 Salon, the jury for the 1884 Salon rejected *Bathing, Asnières*. The painting combined an Impressionistic landscape with a classical figure composition, and the jury may have found it conceptually muddled. Seurat never again submitted work to the Salon.

Georges Seurat.

A number of artists rejected from the 1884 Salon, including Seurat, formed the Société des Artistes Indépendants to exhibit their work without jury review. *Bathing, Asnières* was shown at the first Indépendants exhibition in 1884 but received little critical attention. Seurat relied on the Indépendants as a source of artistic stimulation and fellowship. Through the group he met Paul Signac, whose regular soirées provided the forum for discussions that ultimately led to a loose coalition of Neo-Impressionist painters, with Seurat as leader and theoretician and Signac as standard-bearer.

Immediately after the 1884 Indépendants exhibition, Seurat began work on his next important painting. *A Sunday Afternoon on the Island of the Grande Jatte* is the product of more than a year's labor and dozens of preparatory drawings and paintings. Like *Bathing, Asnières*, the *Grande Jatte* is classically composed, presenting what Seurat hoped would be a contemporary Panathenaic frieze, showing the Parisian working class and bourgeoisie relaxing on a spring Sunday. Through the influence of Camille Pissarro, a recent convert to divisionism, Seurat, Signac, Pissarro, and his son, Lucien, were able to show at the eighth, and last, Impressionist exhibition (1886). There the *Grande Jatte*, along with other divisionist works, debuted to general critical scorn. In the minority, admiring Symbolist critics related the *Grande Jatte*'s flat, profiled figures to Egyptian art. The painting's most dramatic effect, however, was its vibrant and luminous color achieved by short strokes of pigment. After several years of intense experiment in color theory, Seurat's eye had become sensitive to the effect of sunlight and shadow on the local color of objects and to phenomena such as the vibrancy of juxtaposed complementary colors and irradiating halos. Aided by Chevreul's color theories and Ogden Rood's *Modern Chromatics* (French translation, 1881), Seurat found that dots or short strokes of unmixed pigment placed side by side on the canvas could produce, through optical mixture, vibrant colors unattainable when pigments were mixed on the palette. Through optical mixture Seurat was able to achieve an effect comparable to the modulated tones of his conté drawings.

Seurat called his new painting method "chromo-luminarism," which he preferred to "pointillism," a term that describes only the dotted brushwork and not the color theory of his aesthetic. Later, painters and critics adopted "divisionism" as a more euphonious and inclusive term for such works. In an early and sympathetic review (*La Vogue*, June 13–20, 1886), Félix Fénéon invented the term "Neo-Impressionism" for Seurat's orderly method of painting color and light, an advance over the more spontaneous, instinctive approach of "old" Impressionism. An acutely perceptive critic with a gift for vivid language, Fénéon expressed in the pages of small Parisian and Belgian journals his enthusiasm for avant-garde art and literature. With him as their champion, Seurat and Neo-Impressionism moved to the forefront of the Parisian art scene. After the exhibition group Les xx invited Seurat to show the *Grande Jatte* in Brussels in 1887, he figured prominently in the avant-garde of Belgium as well. He exhibited regularly with Les xx until his death, and his method was adopted by several Belgian artists, including Henry van de Velde, Georges Lemmen, and Willy Finch.

After establishing a systematic approach to handling color, Seurat pursued a method for representing the expressive effects of color and line. To Humbert de Superville's theory of the intrinsic expressive qualities of a line's direction, he added his knowledge of Charles Henry's work. A brilliant young mathematician and aesthete, Henry combined mathematics with the results of psychological research on the

Maximilien Luce, *Portrait of Georges Seurat*, 1890. Watercolor, 9 5/8 x 8 1/4 inches (24.5 x 21 cm). Private Collection, Paris.

emotional effects of color and linear movement to produce a "scientific aesthetic." His system recognized the intrinsic power of colors to stimulate emotional responses–roughly, warm hues induce happiness and cool hues sadness. Likewise, he believed a line's direction influences a viewer's feelings. Henry's orderly but complicated system for composing a picture, which included use of an "aesthetic protractor," appealed to Seurat. The first appearance of Henry's theories in Seurat's work may have been the carefully considered placement of the umbrellas and other objects in *The Models* (1886–87). From 1887 all of Seurat's major figure paintings were composed with Henry's system in mind. The enigmatic and artificial world of *The Parade* (1887–88) and the forced gaiety of *The Chahut* (1889–90) are Seurat's fullest treatments of the theories.

Seurat's methodical approach to painting was an outgrowth of his personality. In Paris he rarely varied his daily routine of work, supper at his mother's, and the occasional evening with colleagues. His years assumed a pattern as well. He went to the Channel coast each summer–with the exception of 1887–to paint in the fresh air and light. At Grandcamp in the summer of 1885 he developed the pointillist touch that he carried back to Paris and used to rework the *Grande Jatte*. In the Normandy port of Honfleur during 1886 he painted coastal scenes that show his exquisite control of tone and color. The 1888 summer trip to Port-en-Bessin produced six canvases, which he completed during the winter and exhibited as a group in early 1889 in Brussels with Les xx. His visit in 1889 to Le Crotoy was short, interrupted perhaps by the news that his mistress was pregnant.

In February 1890 Madeleine Knobloch, the subject of *A Young Woman Powdering Herself* (1889–90), gave birth to a son. The three lived in an old building near the Place Pigalle, with Seurat occupying one apartment and Madeleine and the child next door. In March he showed eight paintings and two drawings in the sixth Indépendants exhibition. Most of his reviews were negative. Even his loyal supporter Fénéon declined to write his usual favorable piece. In the spring Seurat was featured in a small review attentive to the Neo-Impressionists, *Les Hommes d'aujourd'hui*. What should have been satisfying exposure turned to frustration when the printer misread and garbled Seurat's explanation of his theories. Seurat spent the summer of 1890 in Gravelines, where the spring's frustrations are not evident in the coastal paintings. In August he recorded his artistic credo in a letter to his friend Maurice Beaubourg. On returning to Paris, he started his last major work, *The Circus*, which owes much of its lively charm to the influence of the popular poster artist Jules Chéret (1836–1932).

By March 1891 Seurat had advanced the unfinished *Circus* enough to show it, along with the Gravelines canvases, in the annual Indépendants show. A few days after the opening, Seurat became ill. The disease, perhaps diphtheritic influenza or meningitis, spread quickly, and he died at his mother's apartment on March 29, 1891, at the age of thirty-one.

After Seurat's death, Neo-Impressionism lost both momentum and adherents. Interest in his work revived in the early twentieth century with the Fauves' enthusiasm for color theory and the Cubists' appreciation of stable forms and systematic painting methods.

Catalogue Documentation

1

The Channel of Gravelines,
Grand Fort Philippe, 1890
Oil on canvas
25 9/16 x 31 7/8 inches (65 x 81 cm)
Signed lower right in painted border: Seurat
Berggruen Collection
(Illustrated on page 17)

Provenance

Mme. Antoine Seurat (artist's mother), Paris;
Léon Appert (artist's brother-in-law), Paris;
Galerie Bignou, Paris; Alexander Reid and
Lefèvre Ltd., London; Samuel Courtauld,
London (1926); The Rt. Hon. Lord R. A. Butler
of Saffron Walden, London (by 1953); Heinz
Berggruen, Geneva (1986).

Exhibitions

Brussels, Le Musée d'Art Moderne (February 7–
March 8, 1891), *8e Exposition des XX*, no. 4.
Paris, Pavillon de la Ville de Paris (March 20–
April 27, 1891), *7e Exposition de la Société
des Artistes Indépendants*, no. 1103.
Paris, La Revue Blanche (March 19–April 5,
1900), *Georges Seurat: Oeuvres peintes et
dessinées*, no. 36 [as *direction de la mer*].
Paris, Grandes Serres de la Ville de Paris (March
24–April 30, 1905), *21e Exposition de la
Société des Artistes Indépendants* (Seurat
retrospective incorporated), no. 3.
Paris, Galeries Bernheim-Jeune (December 14,
1908–January 9, 1909), *Exposition Georges
Seurat*, no. 79 [as *Petit Fort Philippe*].
London, Alexander Reid and Lefèvre Ltd. (April–
May 1926), *Pictures and Drawings of Georges
Seurat*, no. 3 [as *Petit Fort Philippe*].
London, New Burlington Galleries (October 1–
31, 1936), *Masters of French Nineteenth-
Century Painting*, no. 122.
London, Wildenstein Galleries (January 20–
February 27, 1937), *Seurat and His
Contemporaries*, no. 32.
London, Tate Gallery (May 1948), *Samuel
Courtauld Memorial Exhibition*, no. 73.
London, Royal Academy of Arts (December 10,
1949–March 5, 1950), *Landscape in French
Art*, no. 298 (ill. pl. 67).
Paris, Musée de l'Orangerie (Summer 1955),
*Impressionnistes de la Collection Courtauld
de Londres*, no. 56 (ill., col. pl. 76).
London, Royal Academy of Arts (November 17–
March 16, 1980), *Post-Impressionism: Cross-
Currents in European Painting*, no. 205,
pp. 135–36 (ill.).
Geneva, Musée d'art et d'histoire (June 16–
October 30, 1988), *Berggruen Collection*,
no. 26, pp. 74, 75 (col. ill.).

Literature

Retté, A., "Septième exposition des artistes indé-
pendants," *L'Ermitage*, April 1891, p. 294.
Verhaeren, E., "Georges Seurat," *La Société
Nouvelle*, April 1891, p. 435.
Ozenfant, A., and C. Jeanneret, *La peinture
moderne*, Paris, 1925, p. 33 (ill.).
Dormoy, M., "La Collection Courtauld,"
L'Amour de l'Art, February 1929, p. 50 (ill.).
Roger-Marx, C., *Seurat*, Paris, 1931, p. 10.
Jamot, P., and P. Turner, *Collection de tableaux
français faite à Londres par S. et E. Courtauld
entre 1914 et 1931*, London, 1932, p. 29, no.
48 (ill.).
Rewald, J., *Georges Seurat*, New York, 1943,
1946, pp. 73, 114 (ill.).

de Laprade, J., *Georges Seurat*, Monaco, 1945,
p. 54 (ill.).
Rewald, J., *Georges Seurat*, Paris, 1948, p. 143.
Rewald, J., *Seurat*, Paris, 1949, p. 45 (ill.).
Wilenski, R., *Georges Seurat*, London, 1949,
pl. 9.
Clark, K., *Landscape Painting*, New York, 1950,
p. 114, pl. 97.
Venturi, L., *Impressionists and Symbolists*, New
York, 1950, pl. 155.
de Laprade, J., *Georges Seurat*, Paris, n.d.
(ca. 1951), pp. 38, 83 (col. ill).
Wilenski, R., *Georges Seurat*, New York, 1951,
p. 21 (ill.).
Venturi, L., *De Manet à Lautrec*, Paris, 1953,
pp. 201, 203 (ill.), 204.
Cooper, D., *The Courtauld Collection*, London,
1954, p. 118, pl. 52, no. 71.
Dorra, H., and J. Rewald, *Seurat–L'oeuvre peint,
biographie et catalogue critique*, Paris, 1959,
p. 268 (ill.), no. 206.
de Hauke, C., *Seurat et son oeuvre I*, Paris, 1961,
pp. 182, 183 (ill.), no. 205.
Russell, J., *Seurat*, New York, 1965, 1985 (rpt.),
pp. 249, 254, 257, 261 (col. ill.).
Chastel, A., and F. Minervino, *L'opera completa
di Seurat*, Milan, 1972, p. 110.
Lee, E., *The Aura of Neo-Impressionism: The
W. J. Holliday Collection*, Indianapolis, 1983,
p. 62.
Thomson, R., *Seurat*, Oxford, and Salem, NH,
1985, p. 197 (col. ill.).

2

The Channel of Gravelines,
Toward the Sea, 1890
Oil on canvas
28 1/4 x 36 1/4 inches (73 x 93 cm)
Signed lower right in painted border: SEURAT
Rijksmuseum Kröller-Müller, Otterlo,
The Netherlands
(Illustrated on page 19)

Provenance

Madeleine Knobloch, Paris; Léon Appert (artist's
brother-in-law), Paris; Alexandre Braun, Paris
(1892); Théo van Rysselberghe, Brussels
(1908); Galerie Druet, Paris (1913); Mme. H.
Kröller-Müller; Rijksmuseum Kröller-Müller,
Otterlo, The Netherlands (1928).

Exhibitions

Brussels, Le Musée d'Art Moderne (February 7–
March 8, 1891), *8e Exposition des XX*, no. 5.
Paris, Pavillon de la Ville de Paris (March 20–
April 27, 1891), *7e Exposition de la Société des
Artistes Indépendants*, no. 1104.
Brussels, Le Musée d'Art Moderne (February 6–
March 6, 1892), *9e Exposition des XX* (Seurat
retrospective incorporated), no. 18.
Paris, Pavillon de la Ville de Paris (March 19–
April 27, 1892), *8e Exposition de la Société des
Artistes Indépendants* (Seurat retrospective
incorporated), no. 1106.
Brussels, Le Musée d'Art Moderne (February 25–
March 29, 1904), *11e Exposition de la Libre
Esthétique: Exposition des Peintres Impres-
sionnistes*, no. 149.
Paris, Grandes Serres de la Ville de Paris (March
24–April 30, 1905), *21e Exposition de la
Société des Artistes Indépendants* (Seurat
retrospective incorporated), no. 40.
Paris, Galeries Bernheim-Jeune (December 14,
1908–January 9, 1909), *Exposition Georges
Seurat*, no. 80.
Düsseldorf, Kunsthalle (1928), *Sammlung
Kröller-Müller*, no. 432.

Rotterdam, Musée Boymans (December 20, 1934–January 21, 1935), *Soixante-deux tableaux et dessins anciens et modernes des collections néerlandaises*, no. 51 (ill., pl. 28).

Brussels, Palais des Beaux-Arts (June 13–September 20, 1935), *L'Impressionnisme.*

Rotterdam, Musée Boymans (December 23, 1936–January 25, 1937), *Les Divisionnistes de Seurat à Jan Toorop*, no. 43 (ill., pl. II).

Amsterdam, Stedelijk Museum (Summer 1953); and Otterlo, Rijksmuseum Kröller-Müller (1953), *Van Gogh's grote tijdgenoten*, no. 65 (ill.).

Brussels, Exposition Universelle et Internationale (April 17–October 19, 1958), *50 ans d'Art Moderne*, no. 298 (ill.).

Paris, Musée d'Art Moderne (November 4, 1960–January 23, 1961), *Les Sources du xxᵉ Siècle–Les Arts en Europe de 1884 à 1914*, no. 660 (ill.).

Brussels, Musées Royaux des Beaux-Arts (February 17–April 8,1962); and Otterlo, Rijksmuseum Kröller-Müller (April 15–June 17, 1962), *Le groupe des XX et son temps*, no. 129.

Literature

Retté, A., "Septième exposition des artistes indépendants," *L'Ermitage*, April 1891, p. 294.

Meier-Graefe, J., *Entwicklungsgeschicte der Modernen Kunst* I, Stuttgart, 1904, p. 232.

Bremmer, H., ed., *Catalogus versameling Merrauw H. Kröller-Müller*, 1917, no. 315.

Bissière, G., "Notes sur l'art de Seurat," *Esprit Nouveau*, October 15, 1920, p. 25 (ill.).

Lhote, A., *Georges Seurat*, Milan, 1922, pl. 26.

Coquiot, G., *Georges Seurat*, Paris, 1924, p. 249.

Kröller-Müller, H., *Beschouwingen over Problemen in de outwikkeling der Moderne Schilderkunst*, The Hague, 1925, pp. 19, 143 (ill.), 174.

Roger-Marx, C., "Seurat," *Gazette des Beaux-Arts* 16, pér. 5, December 1927, p. 315 (ill.).

George, W., *Seurat et le Divisionnisme*, Paris, 1928, p. 12 (ill.).

de Laprade, J., *Georges Seurat*, Monaco, 1945, pl. 56.

Rewald, J., *Georges Seurat*, New York, 1943, 1946, p. 73.

Rewald, J., *Georges Seurat*, Paris, 1948, p. 143.

Rewald, J., *Seurat*, Paris, 1949, pl. 44.

de Laprade, J., *Georges Seurat*, Paris, n.d. (ca. 1951), pp. 38, 84 (ill.).

Kröller-Müller Catalogue, Otterlo, 1956, no. 614.

Rewald, J., *Post-Impressionism: From van Gogh to Gauguin*, New York, 1956, 1962 (2d ed.), p. 424 (ill.); New York, 1978 (3d ed., rev.), p. 394 (ill.).

Dorra, H., and J. Rewald, *Seurat–L'oeuvre peint, biographie et catalogue critique*, Paris, 1959, pp. lxxiii, 269 (ill.), no. 207.

van Gelder, J., "De haven van Gravelines," *Openbaar Kuntsbezit* 5, 1961, p. 22.

de Hauke, C., *Seurat et son oeuvre* I, Paris, 1961, pp. 184, 185 (ill.), no. 206.

Russell, J., *Seurat*, New York, 1965, 1985 (rpt.), pp. 254, 257 (col. ill).

Chastel, A., and F. Minervino, *L'opera completa di Seurat*, Milan, 1972, col. pl. 59, p. 110 (ill.).

Lee, E., *The Aura of Neo-Impressionism: The W. J. Holliday Collection*, Indianapolis, 1983, p. 62.

Thomson, R., *Seurat*, Oxford, and Salem, NH, 1985, pp. 171, 172 (ill.), 173, 177.

3

The Channel of Gravelines, Petit Fort Philippe, 1890

Oil on canvas
28 ⅞ x 36 ½ inches (73.4 x 92.7 cm)
Signed lower right in painted border: SEURAT
Indianapolis Museum of Art
Gift of Mrs. James W. Fesler in memory of
Daniel W. and Elizabeth C. Marmon
(Illustrated on page 21)

Provenance

Mme. Antoine Seurat (artist's mother), Paris; Léon Appert (artist's brother-in-law), Paris; Léopold Appert (Léon's son), Paris; Alexander Reid and Lefèvre Ltd., London; D. W. T. Cargill, Lanark, Scotland (1935); Bignou Gallery, New York (1937); Knoedler Galleries, New York (1945); Mrs. James W. Fesler, Indianapolis (1945); Indianapolis Museum of Art (1945).

Exhibitions

Brussels, Le Musée d'Art Moderne (February 7–March 8, 1891), *8ᵉ Exposition des XX*, no. 6.

Paris, Pavillon de la Ville de Paris (March 20–April 27, 1891), *7ᵉ Exposition de la Société des Artistes Indépendants*, no. 1105.

Paris, Pavillon de la Ville de Paris (March 19–April 27, 1892), *8ᵉ Exposition de la Société des Artistes Indépendants* (Seurat retrospective incorporated), no. 1105.

Paris, Salon de l'Hôtel Brébant (December 2, 1892–January 8, 1893), *Exposition des Peintres Néo-Impressionnistes*, no. 50.

Paris, La Revue Blanche (March 19–April 5, 1900), *Georges Seurat, Oeuvres peintes et dessinées*, no. 37.

Paris, Galeries Bernheim-Jeune (December 14, 1908–January 9, 1909), *Exposition Georges Seurat*, no. 79 [*Grand Fort Philippe* erroneously cited as *Petit Fort Philippe*].

Paris, Grand Palais (February 20–March 21, 1926), *Trente ans d'Art Indépendant: rétrospective de la Société des Artistes Indépendants*, no. 3217.

London, Alexander Reid and Lefèvre Ltd. (April–May 1926), *Pictures and Drawings of Georges Seurat*, no. 2 [as *Le Port*].

Glasgow, McClellan Galleries (May 1927), *A Century of French Painting*, no. 38 (ill.).

London, Royal Academy of Arts, Burlington House (January 4–March 5, 1932), *Exhibition of French Art*, no. 559 of official catalogue, no. 513 of commemorative catalogue.

Liverpool, Walker Art Gallery (1933), *French Art*, no. 586.

Toronto, Art Gallery of Ontario (November 1935), *Loan Exhibition of Paintings*, no. 194.

London, Wildenstein Galleries (January 20–February 27, 1937), *Seurat and His Contemporaries*, no. 32.

New York, Bignou Gallery (March–April 1937), *The Post-Impressionists*, no. 10 (ill.).

London, Alexander Reid and Lefèvre Ltd. (July–August 1937), *The 19th-Century French Masters*, no. 45.

Providence, Rhode Island School of Design, Museum of Art (November 1942), *French Art of the 19th and 20th Centuries*, no. 64.

New York, Bignou Gallery (November 1–December 4, 1943), *Twelve Masterpieces by 19th-Century French Painters*, no. 12.

Rochester, NY, Rochester Memorial Art Gallery (April–May 1944), *Old Masters of Modern Art.*

Indianapolis, Indianapolis Museum of Art
(September–October 1976), *Caroline Marmon
Fesler Collection.*

Literature

Retté, A., "Septième exposition des artistes indé-
pendants," *L'Ermitage*, April 1891, p. 294.

Meier-Graefe, J., *Entwicklungsgeschicte der
Modernen Kunst* I, Stuttgart, 1904, p. 232.

Coustourier, L., *Georges Seurat*, Paris, 1921 (ill.
25, erroneously cited as *The Channel of Grave-
lines, Petit Fort Philippe*, actually shows *Le
Fort Samson à Grandcamp*, 1885).

Coquiot, G., *Georges Seurat*, Paris, 1924, pp.
153, 222.

Fry, R., *Transformations*, London, 1926, p. 145,
opp. p. 195 (ill.).

"The Harbour," *Cahiers d'Art* 8, October 1926,
p. 209 (ill.).

Ozenfant, A., and C. Jeanneret, *La Peinture
Moderne*, Paris, 1927, p. 33 (ill.).

La Revue de l'art 61, February 1932, p. 103 (ill.).

Davidson, M., "The Post-Impressionists in
Review," *The Art News* 35, no. 24, March 13,
1937, pp. 9, 10 (ill.).

Bertram, *Journal Royal Society of Arts*, January
19, 1940, p. 233 (ill.).

Rewald, J., *Seurat*, New York, 1943, 1946, pp.
72–73, 115 (ill.).

"Masters of France's Golden Century," *Art
Digest*, November 15, 1943, p. 11 (ill.).

de Laprade, J., *Georges Seurat*, Monaco, 1945,
p. 60 (ill.).

"Two Recently Acquired Paintings in the John
Herron Art Institute," *Art Quarterly* 8, no. 2,
Spring 1945, pp. 116, 167 (ill.).

"Two XIXth-Century Canvases for Indianapolis,"
The Art News 44, no. 10, August 1945, p. 29
(ill.).

Stillson, B., "Port of Gravelines (Petit Fort Phi-
lippe) by Georges Seurat," *Bulletin of the Art
Association of Indianapolis* 32, no. 2, October
1945, pp. 25 (ill.), 26–27.

"Seurat's *Le port de Gravelines* for the John
Herron Institute," *Connoisseur* 117, no. 449,
March 1946, pp. 47, 52 (ill.).

Rewald, J., *Georges Seurat*, Paris, 1948, pp. 141
(ill.), 143.

The Marmon Memorial Collection of Paintings,
John Herron Art Institute, Indianapolis, 1948,
pp. 36, 37 (col. ill.), 38–40.

"The Indianapolis Way to Collect," *Art News* 48,
no. 1, March 1949, pp. 1 (col. ill.), 41.

de Laprade, J., *Georges Seurat*, Paris, n.d. (ca.
1951), pp. 38, 82 (ill.).

Cassou, J., *Les Impressionnistes et leur époque*,
Paris and Lucerne, 1953, p. 84 (ill.).

Taylor, B., *The Impressionists and Their World*,
London, 1953, p. 84 (ill.).

Stillson, B., ed., *Tribute to Caroline Marmon
Fesler, Collector*, Indianapolis, 1961, no. 10
(ill.).

Rewald, J., *Post-Impressionism: From van Gogh
to Gauguin*, New York, 1956, 1962 (2d ed.),
p. 123 (ill.); New York, 1978 (3d ed., rev.),
p. 115 (ill.).

Herbert, R., "Seurat in Chicago and New York,"
The Burlington Magazine 100, no. 662, May
1958, p. 155.

Dorra, H., and J. Rewald, *Seurat—L'oeuvre peint,
biographie et catalogue critique*, Paris, 1959,
pp. lxxiii, cii (ill.), 267 (ill.), no. 205.

Muller, J., *Seurat*, Paris, 1960, no. 16 (ill.)

de Hauke, C., *Seurat et son oeuvre* I, Paris, 1961,
pp. 186, 187 (ill.), no. 208.

Herbert, R., *Seurat's Drawings*, New York, 1962,
p. 154.

Fry, R., and A. Blunt, *Seurat*, Greenwich, CT,
1965, pp. 21, 84, pl. 44 (col. ill.).

Russell, J., *Seurat*, New York, 1965, 1985 (rpt.),
pp. 249–51, 256 (col. ill.).

Courthion, P., *Georges Seurat*, New York, 1968,
pp. 154, 155 (col. ill.).

Miller, D., *A Catalogue of European Paintings,
Indianapolis Museum of Art*, Indianapolis,
1970, pp. 198 (ill.), 199.

Hamilton, G., *19th- and 20th-Century Art*, New
York, 1970, p. 123, col. pl. 20.

Prak, N., "Seurat's Surface Pattern and Subject
Matter," *The Art Bulletin* 53, no. 3, September
1971, pp. 372, 375, 376 (ill.)

Chastel, A., and F. Minervino, *L'opera completa
di Seurat*, Milan, 1972, col. pl. 58, p. 110 (ill.).

Shone, R., *The Post-Impressionists*, London,
1979, p. 25 (ill.).

Alexandrian, S., *Seurat*, New York, 1980, pp. 80,
90 (col. ill.).

Janson, A., *100 Masterpieces of Painting*, Indian-
apolis, 1980, pp. 189, 190 (ill.).

Hughes, R., *The Shock of the New*, London,
1980, p. 114, 115 (col. ill.).

Lee, E., *The Aura of Neo-Impressionism: The
W. J. Holliday Collection*, Indianapolis, 1983,
pp. 62, 63 (col. ill.), 64–65.

Rosenblum, R., and H. Janson, *19th-Century
Art*, New York, 1984, p. 404 (ill.).

Stuckey, C., *Seurat*, Mount Vernon, NY, 1984,
pl. 9.

Thomson, R., *Seurat*, Oxford, and Salem, NH,
1985, pp. 171, 173, 181, 194 (col. ill.).

Sackerlotzky, R., "Giovanni Segantini: *Stone Pine
and Alpine Roses*," *The Bulletin of the Cleve-
land Museum of Art* 73, no. 1, January 1986,
p. 8 (ill.).

4

*The Channel at Gravelines,
Evening,* 1890

Oil on canvas
25 ¼ x 32 ¼ inches (65.4 x 81.9 cm)
Signed lower right in painted border: Seurat
Collection, The Museum of Modern Art,
New York
Gift of Mr. and Mrs. William A. M. Burden
(Illustrated on page 23)

Provenance

Madeleine Knobloch, Paris; Mme. Monnom,
Brussels (1892); Théo van Rysselberghe, Brus-
sels; Galerie Druet, Paris (1913); Alfred Flech-
theim Gallery, Berlin; Rolf de Maré, Paris; Paul
Rosenberg Galleries, New York; Mr. and Mrs.
William A. M. Burden, New York (1948); The
Museum of Modern Art, New York (1963).

Exhibitions

Brussels, Le Musée d'Art Moderne (February 7–
March 8, 1891), *8ᵉ Exposition des XX*, no. 7.

Paris, Pavillon de la Ville de Paris (March 20–
April 27, 1891), *7ᵉ Exposition de la Société des
Artistes Indépendants*, no. 1106.

Brussels, Le Musée d'Art Moderne (February 6–
March 6, 1892), *9ᵉ Exposition des XX* (Seurat
retrospective incorporated), no. 17.

Paris, Pavillon de la Ville de Paris (March 19–
April 27, 1892), *8ᵉ Exposition de la Société des
Artistes Indépendants* (Seurat retrospective
incorporated), no. 1107.

Antwerp, Association pour l'Art (1892), no. 6.

Paris, Salon de l'Hôtel Brébant (December 2, 1892–January 8, 1893), *Expositions des peintres Néo-Impressionnistes*, no. 51.

Vienna (January–February 1903), *Wiener Secession*, no. 117.

Brussels (February–March 1904), *11e Exposition de la Libre Esthétique: Exposition des Peintres Impressionnistes*, no. 150.

Paris, Grandes Serres de la Ville de Paris (March 24–April 30, 1905), *21e Exposition de la Société des Artistes Indépendants* (Seurat retrospective incorporated), no. 39.

Paris, Galeries Bernheim-Jeune (December 14, 1908–January 9, 1909), *Exposition Georges Seurat*, no. 81.

Düsseldorf, Alfred Flechtheim Gallery (1913), *Beiträge zur Kunst des 19. Jahrhunderts und unserer Zeit*.

Stockholm (1918), *L'Art Français*.

Berlin, Alfred Flechtheim Gallery (1928), *Seurat*.

Düsseldorf, Kunsthalle (1928), *Sammlung Kröller-Müller*, no. 432.

Paris, Galerie Paul Rosenberg (May 18–June 27, 1931), *Oeuvres Importantes des Grands Maîtres de XIXe Siècle*, no. 75.

Paris, Gazette des Beaux-Arts (December 1933–January 1934), *Seurat et ses amis*, no. 61.

Brussels, Palais des Beaux-Arts (June 15–September 29, 1935), *L'Impressionnisme*, no. 77.

Paris, Galerie Paul Rosenberg (February 3–29, 1936), *Exposition Seurat*, no. 51 (ill.).

London, New Burlington Galleries (October 1–31, 1936), *Masters of French Nineteenth-Century Painting*, no. 123.

New York, Paul Rosenberg Galleries (1940), no. 24 (ill.).

New York, Knoedler Galleries (April 10–May 7, 1949), *Seurat: Paintings and Drawings*, no. 20 (ill.).

New York, Paul Rosenberg Galleries (March 7–April 11, 1950), *The Nineteenth-Century Heritage*, no. 24 (ill.).

New York, Paul Rosenberg Galleries (March 17–April 18, 1953), *Collector's Choice*, no. 4 (ill.).

New York, Wildenstein Galleries (November 18–December 26, 1953), *Seurat and His Friends*, no. 15a (ill.).

Paris, Musée de l'Orangerie (April 21–July 3, 1955), *De David à Toulouse-Lautrec, Chefs d'Oeuvre des Collections et des Musées Américains*, no. 53 (ill., pl. 87).

Chicago, The Art Institute of Chicago (January 20–February 20, 1955), *Great French Paintings*, no. 37 (ill.).

Chicago, The Art Institute of Chicago (January 16–March 7, 1958), and New York, The Museum of Modern Art (March 24–May 11, 1958), *Seurat: Paintings and Drawings*, no. 149 (ill.).

New York, The Museum of Modern Art (October 8–November 9, 1958), *Works of Art: Given or Promised*.

Washington, D.C., National Gallery of Art (April 25–May 4, 1959), *Masterpieces of Impressionist and Post-Impressionist Painting*.

Brussels, Palais des Beaux-Arts (February 27–March 15, 1961), *Collection de M. et Mme. William A. M. Burden*.

New York, Harvard Club (May 3–9, 1965), *Group Show for Club's Centennial*.

New York, The Solomon R. Guggenheim Museum (February 9–April 7, 1968), *Neo-Impressionism*, pp. 126 (ill.), 127, no. 89.

Leningrad, The Hermitage Museum (October 17–November 28, 1989), *Jubilee Exhibition*.

Literature

Retté, A., "Septième exposition des artistes indépendants," *L'Ermitage*, April 1891, p. 294.

Meier-Graefe, J., *Entwicklungsgeschicte der Modernen Kunst* I, Stuttgart, 1904, p. 232.

Bissière, G., "Seurat," *Esprit Nouveau*, October 15, 1920, p. 20 (ill.).

Lhote, A., *Georges Seurat*, Rome, 1922, p. 14 (ill.).

Asplund, K., *Rolf de Maré's travelsamling*, Stockholm, 1923, p. 19 (ill.).

Coquiot, G., *Georges Seurat*, Paris, 1924, p. 244.

Cousturier, L., *Georges Seurat*, Paris, 1926, pl. 34.

George, W., *Seurat et le Divisionnisme*, Paris, 1928, p. 11 (ill.).

Niehaus, K., "Seurat," *Elsevier's Geillustred Maandschrift* 79, January–July 1930, opp. p. 308 (ill.).

Roger-Marx, C., *Seurat*, Paris, 1931, p. 18 (ill.).

Deene, J., "Georges Seurat," *Maanblad voor Beeldende Kunsten*, June 6, 1931, p. 169 (ill.).

Lord, D., "The Impressionists at the Palais des Beaux-Arts," *The Burlington Magazine* 67, no. 389, August 1935, p. 87.

Watt, A., "Seurat," *Apollo*, March 1936, p. 168 (ill.).

Hélion, J., "Seurat as a Predecessor," *The Burlington Magazine* 69, no. 400, July 1936, pp. 4, 9, pl. 1.

Laver, J., *French Painting*, London and New York, 1937, p. 137 (ill.).

Frost, R., "Contemporary Art," *New York*, 1942, p. 34 (ill.).

Rewald, J., *Georges Seurat*, New York, 1943, 1946, pp. 73, 113 (ill.).

Michel, G., *Chefs-d'oeuvre de la Peinture Contemporaine*, New York, 1945, p. 58 (ill.).

de Laprade, J., *Georges Seurat*, Monaco, 1945, p. 58 (ill.).

Rewald, J., *Georges Seurat*, Paris, 1948, pp. 141 (ill.), 143.

Rewald, J., "Seurat: The Meaning of the Dots," *Art News* 48, April 1949, p. 27 (ill.).

Cogniat, R., *Seurat*, Paris, n.d. (ca. 1951), pl. 27.

de Laprade, J., *Seurat*, Paris, n.d. (ca. 1951), pp. 38, 85 (ill.).

Rewald, J., *Post-Impressionism: From van Gogh to Gauguin*, New York, 1956, 1962 (2d ed.), p. 424 (ill.); New York, 1978 (3d ed., rev.), p. 394 (ill.).

Huyghe, R., ed., *L'Art et l'Homme* I, November 1957, fig. 16.

Museum of Modern Art Bulletin 6, no. 1, Fall 1958, p. 47 (ill.).

Herbert, R., "Seurat in Chicago and New York," *The Burlington Magazine* 100, no. 662, May 1958, p. 155.

Dorra, H., and J. Rewald, *Seurat—L'oeuvre peint, biographie et catalogue critique*, Paris, 1959, pp. 264, 265 (ill.), no. 203.

de Hauke, C., *Seurat et son oeuvre* I, Paris, 1961, pp. 188, 189 (ill.), no. 210.

Russell, J., *Seurat*, New York, 1965, 1985 (rpt.), pp. 249, 252 (col. ill.).

Chastel, A., and F. Minervino, *L'opera completa di Seurat*, Milan, 1972, col. pl. 60, p. 110 (ill.).

Lee, E., *The Aura of Neo-Impressionism: The W. J. Holliday Collection*, Indianapolis, 1983, p. 62.

Thomson, R., *Seurat*, Oxford, and Salem, NH, 1985, pp. 171, 173, 195 (col. ill.).

5

Study for *The Channel of Gravelines, Petit Fort Philippe*, 1890
Oil on panel
6 3/8 x 9 7/8 inches (16 x 24.7 cm)
Unsigned
Private Collection, Tokyo
(Illustrated on page 34)

Provenance

Maximilien Luce, Paris; Sale: London, Sotheby Parke Bernet (December 6, 1978), no. 216; Private Collection, Tokyo.

Exhibitions

Paris, Grandes Serres de la Ville de Paris (March 24–April 30, 1905), 21ᵉ *Exposition de la Société des Artistes Indépendants* (Seurat retrospective incorporated), no. 43.
Munich, Kunstverein (September 1906); Frankfurt, Kunstverein (October 1906); Dresden, Galerie Arnold (November 1906); Karlsruhe, Kunstverein (December 1906); and Stuttgart, Kunstverein (January 1907), *Französiche Kunstler*, no. 101.
Paris, Galeries Bernheim-Jeune (December 14, 1908–January 9, 1909), *Exposition Georges Seurat*, no. 78.
Paris, Galerie d'Art Braun et Cie (February 25–March 17, 1932), *Le Néo-Impressionnisme*, no. 22.
Paris, Galerie des Beaux-Arts (December 1933–January 1934), *Seurat et ses amis*, no. 64.
Tokyo, The National Museum of Western Art (April 6–May 26, 1985); and Kyoto, Municipal Art Museum (June 4–July 14, 1985), *Exposition du Pointillisme*, no. 20.

Literature

Coquiot, G., *Georges Seurat*, Paris, 1924, pp. 153, 222.
de Laprade, J., *Georges Seurat*, Monaco, 1945, p. 59 (ill.).
Jedding, H., *Seurat*, Milan, n.d. (ca. 1950), p. 20, col. pl. 7.
de Laprade, J., *Georges Seurat*, Paris, n.d. (ca. 1951), pp. 38, 81 (col. ill.).
Dorra, H., and J. Rewald, *Seurat—L'oeuvre peint, biographie et catalogue critique*, Paris, 1959, p. 266 (ill.), no. 204.
de Hauke, C., *Seurat et son oeuvre I*, Paris, 1961, p. 186 (ill.), no. 207.
Chastel, A., and F. Minervino, *L'opera completa di Seurat*, Milan, 1972, p. 110 (ill.).
Sotheby Parke Bernet, *Art at Auction: The Year at Sotheby Parke Bernet 1978–79*, London, 1979, p. 94 (col. ill.).
Lee, E., *The Aura of Neo-Impressionism: The W. J. Holliday Collection*, Indianapolis, 1983, p. 62.
Thomson, R., *Seurat*, Oxford, and Salem, NH, 1985, pp. 171, 190 (col. ill).

6

Study for *The Channel at Gravelines, Evening*, 1890
Oil on panel
6 3/8 x 10 inches (16 x 25.2 cm)
Unsigned
Musée de l'Annonciade, St. Tropez
(Illustrated on page 41, not in exhibition)

Provenance

Paul Signac, Paris; Mme. Ginette Signac, Paris; Georges Grammont, Paris; Musée de l'Annonciade, St. Tropez.

Exhibitions

Paris, Grandes Serres de la Ville de Paris (March 24–April 30, 1905), 21ᵉ *Exposition de la Société des Artistes Indépendants* (Seurat retrospective incorporated), no. 25.
Paris, Galeries Bernheim-Jeune (December 14, 1908–January 9, 1909), *Exposition Georges Seurat*, no. 78 *bis*.
Paris, Galerie de France (December 12, 1942–January 15, 1943), *Le Néo-Impressionnisme*.
Amsterdam, Rijksmuseum (March 18–June 4, 1951), *Het Franse Landschap*, no. 128.
Venice (1952), XXVIᵉ *Biennale Il Divisionismo*, no. 19.

Literature

de Laprade, J., *Georges Seurat*, Monaco, 1945, p. 57 (ill.).
de Laprade, J., *Georges Seurat*, Paris, n.d. (ca. 1951), p. 38.
Dorra, H., and J. Rewald, *Seurat—L'oeuvre peint, biographie et catalogue critique*, Paris, 1959, p. 264 (ill.), no. 202.
de Hauke, C., *Seurat et son oeuvre I*, Paris, 1961, pp. 188, 189 (ill.), no. 209.
Russell, J., *Seurat*, New York, 1965, 1985 (rpt.), pp. 249, 250, 251 (ill.).
Chastel, A., and F. Minervino, *L'opera completa di Seurat*, Milan, 1972, p. 110 (ill.).
Thomson, R., *Seurat*, Oxford, and Salem, NH, 1985, p. 173.

7

The Clipper, 1890
Conté crayon on Michallet paper
9 1/4 x 12 3/8 inches (23.5 x 31.5 cm)
Solomon R. Guggenheim Museum, New York
Gift of Solomon R. Guggenheim, 1937
(Illustrated on page 35)

Provenance

Seurat family, Paris; Félix Fénéon, Paris; Solomon R. Guggenheim, New York (1936); The Solomon R. Guggenheim Museum, New York (1937).

Exhibitions

Paris, La Revue Blanche (March 19–April 5, 1900), *Georges Seurat: Oeuvres peintes et dessinées* (not in catalogue).
Paris, Galeries Bernheim-Jeune (December 14, 1908–January 9, 1909), *Exposition Georges Seurat*, no. 203.
Paris, Galeries Bernheim-Jeune (January 15–31, 1920), *Exposition Georges Seurat*, no. 47.
Paris, Galerie Devambez (October 1922), *Vingt Dessins de Seurat*, no. 18.
Paris, Galeries Bernheim-Jeune (November 29–December 24, 1926), *Les Dessins de Georges Seurat*, no. 89.
Paris, Galerie Bernier (May 25–June 13, 1929), *Mers et Plages de Delacroix à nos jours*, no. 20.
Charleston, South Carolina, Gibbes Memorial Art Gallery (March 1–April 12, 1936), *Solomon R. Guggenheim Collection of Non-Objective Paintings*, p. 41, no. 126.
Philadelphia, Philadelphia Art Alliance (February 8–28, 1937), *Solomon R. Guggenheim Collection of Non-Objective Paintings*, p. 47, no. 195.

Charleston, South Carolina, Gibbes Memorial
Art Gallery (March 7–April 17, 1938), *Solomon R. Guggenheim Collection of Non-Objective Paintings*, p. 61, no. 269.

New York, Museum of Non-Objective Painting
(opened June 1, 1939), *Art of Tomorrow*,
p. 175, no. 718.

New York, The Solomon R. Guggenheim
Museum (February 4–May 3, 1953), *A Selection*.

Vancouver, Vancouver Art Gallery (November
16–December 12, 1954), *The Solomon R. Guggenheim Museum: A Selection from the Museum Collection*, no. 76.

Chicago, The Art Institute of Chicago (January
16–March 7, 1958), and New York, The
Museum of Modern Art (March 24–May 11,
1958), *Seurat: Paintings and Drawings*,
no. 145.

New York, The Solomon R. Guggenheim
Museum (August 30–October 8, 1961),
Modern Masters from the Collection of The Solomon R. Guggenheim Museum.

Philadelphia, Philadelphia Museum of Art
(November 2, 1961–January 7, 1962),
Guggenheim Museum Exhibition: A Loan Collection of Paintings, Drawings, and Prints from The Solomon R. Guggenheim Museum, New York, no. 144.

New York, The Solomon R. Guggenheim
Museum (April 23–September 18, 1966),
Museum Collection.

New York, The Solomon R. Guggenheim
Museum (September 16–October 12, 1969),
Collection: From the Turn of the Century to 1914.

New York, The Solomon R. Guggenheim
Museum (May 1–September 13, 1970),
Selections from the Museum Collections, 1900–1970 (ill.).

New York, The Solomon R. Guggenheim
Museum (June 11–September 12, 1971), *Selections from the Museum Collection and Recent Acquisitions, 1971*.

New York, The Solomon R. Guggenheim
Museum (May 9–August 27, 1972), *Classics from the Collection*.

New York, Metropolitan Museum of Art (September 29–November 27, 1977), *Seurat: Drawings and Oil Sketches from New York Collections*, no. 43.

Literature

Coquiot, G., *Georges Seurat*, Paris, 1924, p. 251.

Kahn, G., *Les Dessins de Georges Seurat* II, Paris,
1928, pl. 73; New York, 1971 (new ed.), pl. 93.

Dorra, H., and J. Rewald, *Seurat—L'oeuvre peint, biographie et catalogue critique*, Paris,
1959, p. 266 (ill.), no. 204a.

The Solomon R. Guggenheim Museum, *A Handbook to the Solomon R. Guggenheim Museum Collection*, New York, 1959, p. 262, pl. 240.

de Hauke, C., *Seurat et son oeuvre* II, Paris, 1961,
pp. 292, 293 (ill.), no. 703.

Chastel, A., and F. Minervino, *L'opera completa di Seurat*, Milan, 1972, p. 110 (ill.).

Thomson, R., *Seurat*, Oxford, and Salem, NH,
1985, pp. 171, 172 (ill.), 173.

8
Evening, 1890
Conté crayon on Michallet paper
9 7/16 x 12 5/16 inches (24 x 31.2 cm)
André Bromberg Collection, Paris
(Illustrated on page 42)

Provenance
Léon Appert (artist's brother-in-law), Paris; Mme.
Léon Roussel, Paris; Private Collection, Paris;
Sale: Paris, Ader Picard Tajan (June 22, 1988),
no. 3; André Bromberg, Paris.

Exhibitions
Paris, Musée Jacquemart-André (November–
December 1957), *Seurat*, no. 44 [as *Port-en-Bessin*].

Literature
Dorra, H., and J. Rewald, *Seurat—L'oeuvre peint, biographie et catalogue critique*, Paris,
1959, p. 262 (ill.), no. 202a.

Muller, J., *Seurat—Dessins*, Paris, 1960, p. 35
(ill.).

de Hauke, C., *Seurat et son oeuvre* II, Paris, 1961,
pp. 288, 289 (ill.), no. 696.

Herbert, R., *Seurat's Drawings*, New York, 1962,
pp. 154, 155 (ill.), 186.

Chastel, A., and F. Minervino, *L'opera completa di Seurat*, Milan, 1972, p. 110 (ill.).

Thomson, R., *Seurat*, Oxford, and Salem, NH,
1985, p. 173.

9
Boats and Anchors, 1890
Conté crayon on Michallet paper
8 3/4 x 11 3/4 inches (sight) (22.2 x 29.8 cm)
Private Collection, USA
(Illustrated on page 43)

Provenance
Seurat and Appert families; Galerie Bignou, Paris;
Chester H. Johnson, Chicago; Mrs. Henry D.
Sharpe, Providence, Rhode Island; Private
Collection, USA.

Exhibitions
London, Alexander Reid and Lefèvre Ltd. (April–
May 1926), *Pictures and Drawings of Georges Seurat*, no. 16.

Chicago, The Renaissance Society of the University of Chicago (February 5–25, 1935),
Twenty-four Paintings and Drawings by Georges-Pierre Seurat, no. 12.

St. Paul, Minnesota, St. Paul Gallery and School
of Art (November 1–25, 1943), *French Art 1900–1938*, no. 4.

Vancouver, Vancouver Art Gallery (March 24–
April 19, 1953), *The French Impressionists*,
no. 88.

New York, Wildenstein Galleries (November–
December 1953), *Seurat and His Friends*,
no. 165.

New York, Wildenstein Galleries (September 24–
October 31, 1956), *For the Connoisseur*,
no. 63.

Caracas (May 24–June 9, 1957) *Exposicion de dibujos del renacimiento al siglo* XX, no. 48.

New York, Wildenstein Galleries (February–
March 1973), *Master Drawings*.

Bielefeld, Kunsthalle (October 30–December 25,
1983); Baden-Baden, Staatliche Kunsthalle
(January 15–March 11, 1984); and Zurich,
Kunsthaus (closed May 15, 1984), *Georges Seurat: Zeichnungen*, no. 84.

12

Literature

Rewald, J., *Georges Seurat*, New York, 1943, 1946, p. 70 (ill.).

Seligman, G., *The Drawings of Georges Seurat*, New York, 1947, p. 62, no. 25.

Rewald, J., *Georges Seurat*, Paris, 1948, p. 140 (ill.).

Dorra, H., and J. Rewald, *Seurat—L'oeuvre peint, biographie et catalogue critique*, Paris, 1959, p. 263 (ill.), no. 202c.

de Hauke, C., *Seurat et son oeuvre* II, Paris, 1961, pp. 288, 289 (ill.), no. 697.

Herbert, R., *Neo-Impressionism*, The Solomon R. Guggenheim Museum, New York, 1968, p. 126, cited under no. 84.

Chastel, A., and F. Minervo, *L'opera completa di Seurat*, Milan, 1972, p. 110 (ill.).

Hautecoeur, L., *Georges Seurat*, Milan, 1972, p. 64 (ill.).

Thomson, R., *Seurat*, Oxford, and Salem, NH, 1985, p. 173.

10

The Anchors, 1890

Conté crayon on Michallet paper
9 ⅛ x 12 ⅜ inches (23.8 x 31.5 cm)
Board of Trustees of the Victoria and Albert
Museum, London
(Illustrated on page 45)

Provenance

Emile Seurat (artist's brother), Paris; Edouard Vuillard; M. Jacques Roussel; Antoine Salomon; Victoria and Albert Museum, London.

Exhibitions

Paris, La Revue Blanche (March 19–April 5, 1900), *Seurat: Oeuvres peintes et dessinées* (not in catalogue).

Paris, Galeries Bernheim-Jeune (November 29– December 24, 1926), *Les Dessins de Georges Seurat*, no. 136.

Paris, Galerie Paul Rosenberg (February 3–29, 1936), *Exposition Georges Seurat*, no. 129.

Literature

Natanson, T., "Un primitif d'aujourd'hui: G. Seurat," *La Revue Blanche*, April 15, 1900, p. 614 (ill.).

Kahn, G., *Les Dessins de Georges Seurat* II, Paris, 1928, pl. 115; New York, 1971 (new ed.), pl. 135.

Dorra, H., and J. Rewald, *Seurat—L'oeuvre peint, biographie et catalogue critique*, Paris, 1959, p. 263 (ill.), no. 202d.

de Hauke, C., *Seurat et son oeuvre* II, Paris, 1961, pp. 288, 289 (ill.), no. 698.

Chastel, A., and F. Minervino, *L'opera completa di Seurat*, Milan, 1972, p. 110 (ill.).

Terrasse, A., *Universe de Seurat, Les Carnets de Dessin*, Paris, 1976.

Thomson, R., *Seurat*, Oxford, and Salem, NH, 1985, p. 173.

11

Sailboats, 1890

Conté crayon on Michallet paper
9 1/16 x 12 3/16 inches (23 x 31 cm)
Henri Cachin, Paris
(Illustrated on page 46, not in exhibition)

Provenance

Paul Signac and Mme. Berthe Paul-Signac; Mme. Ginette Signac; Henri Cachin, Paris.

Exhibitions

Paris, Galeries Bernheim-Jeune (November 29– December 24, 1926), *Les Dessins de Georges Seurat*, no. 123.

Literature

Kahn, G., *Les Dessins de Georges Seurat* II, Paris, 1928, pl. 106; New York, 1971 (new ed.), pl. 126.

Dorra, H., and J. Rewald, *Seurat—L'oeuvre peint, biographie et catalogue critique*, Paris, 1959, p. 262 (ill.), no. 202b.

de Hauke, C., *Seurat et son oeuvre* II, Paris, 1961, pp. 292, 293 (ill.), no. 702 [as *En direction de la mer*].

Chastel, A., and F. Minervino, *L'opera completa di Seurat*, Milan, 1972, p. 110 (ill.).

Thomson, R., *Seurat*, Oxford, and Salem, NH, 1985, p. 171.

Appendix

The following works were executed at Gravelines during the summer of 1890 but do not relate specifically to the four Gravelines canvases.

12

Seascape, 1890

Oil on panel
6 ¼ x 9 ⅞ inches (15.9 x 25.1 cm)
Present location unknown
(Not in exhibition)

Provenance

Alfred Tobler, Paris; Galeries Bernheim-Jeune, Paris; Mme. Théry; present location unknown.

Exhibitions

Paris, Galeries Bernheim-Jeune (June 19–30, 1916), *Peinture*, no. 70.

Literature

Dorra, H., and J. Rewald, *Seurat—L'oeuvre peint, biographie et catalogue critique*, Paris, 1959, p. 260 (ill.), no. 200.

de Hauke, C., *Seurat et son oeuvre* I, Paris, 1961, pp. 180, 181 (ill.), no. 201.

Dorra, H., "Seurat's Dot and the Japanese Stippling Technique," *The Art Quarterly* 33, no. 2, Summer 1970, pp. 110, 112 (ill.).

Chastel, A., and F. Minervino, *L'opera completa di Seurat*, Milan, 1972, pp. 109 (ill.), 110.

13

14

15

13
Trees and Boats, 1890
Oil on panel
6 ¼ x 9 ¾ inches (15.9 x 25.4 cm)
A. & R. Ball, New York
(Not in exhibition)

Provenance
Alfred Tobler, Paris; Galeries Bernheim-Jeune, Paris; Princesse de Bassiano; Georges Bernheim; De Hauke and Co., New York; Joseph Hessel; Sacha Guitry, Paris; Private Collection, Switzerland; A. & R. Ball, New York (by 1959).

Exhibitions
Paris, Galeries Bernheim-Jeune (June 19–30, 1916), *Peinture*, no. 69.
Paris, Galeries Bernheim-Jeune (January 15–31, 1920), *Exposition Georges Seurat*, no. 33.
Venice (1920), XIIa *Esposizione Internazionale d'Arte della Citta di Venezia*, no. 54.

Literature
Coquiot, G., *Georges Seurat*, Paris, 1924, p. 249.
Nebesky, V., "Kolem Seurata," *Zivot*, 1934, p. 160 (ill.).
Dorra, H., and J. Rewald, *Seurat—L'oeuvre peint, biographie et catalogue critique*, Paris, 1959, p. 271 (ill.), no. 209.
de Hauke, C., *Seurat et son oeuvre* I, Paris, 1961, pp. 180, 181 (ill.), no. 202.
Russell, J., *Seurat*, New York, 1965, 1985 (rpt.), p. 250 (ill.).
Chastel, A., and F. Minervino, *L'opera completa di Seurat*, Milan, 1972, pp. 109 (ill.), 110.

14
Moored Boats and Trees, 1890
Oil on panel
6 ⅛ x 9 ⅞ inches (15.5 x 25 cm)
Private Collection, USA
(Not in exhibition)

Provenance
Alfred Tobler, Paris; Galeries Bernheim-Jeune, Paris; Henri Matisse, Paris; Pierre Matisse, New York; Private Collection, USA.

Exhibitions
Paris, Galerie Paul Rosenberg (February 3–29, 1936), *Exposition Seurat*, no. 51 *bis*.

Literature
Dorra, H., and J. Rewald, *Seurat—L'oeuvre peint, biographie et catalogue critique*, Paris, 1959, p. 270 (ill.), no. 208.
de Hauke, C., *Seurat et son oeuvre* I, Paris, 1961, pp. 180, 181 (ill.), no. 203.
Chastel, A., and F. Minervino, *L'opera completa di Seurat*, Milan, 1972, pp. 109 (ill.), 110.

15
Beach at Gravelines, 1890
Oil on panel
6 ¼ x 9 ¼ inches (16 x 24.5 cm)
Courtauld Institute Galleries, London
Courtauld Collection
(Not in exhibition)

Provenance
Mme. Antoine Seurat (artist's mother), Paris; Alfred Tobler, Paris; Galeries Bernheim-Jeune, Paris; Alphonse Kann, Saint Germain-en-Laye; Galerie Bignou, Paris; Alexander Reid and Lefèvre Ltd., London; Samuel Courtauld, London (by 1928); Courtauld Institute Galleries, The Home House Trustees, London (1948).

Exhibitions
Paris, Galeries Bernheim-Jeune (December 14, 1908–January 9, 1909), *Exposition Georges Seurat*, no. 78.
Paris, Galeries Bernheim-Jeune (January 15–31, 1920), *Exposition Georges Seurat*, no. 31.
Venice (1920), XIIa *Esposizione Internazionale d'Arte della Citta di Venezia*, no. 56.
Paris, Galerie E. J. van Wisselingh & Co. (April 16–May 5, 1928), *Cent Ans de Peinture Française*, no. 59.
London, Wildenstein Galleries (January 20–February 27, 1937), *Seurat and His Contemporaries*, no. 34.
London, The Tate Gallery (1948), *Courtauld Memorial Exhibition*, no. 293.
London, Royal Academy of Arts (December 10, 1949–March 5, 1950), *Landscape in French Art*, no. 293.
Paris, Musée de l'Orangerie (Summer 1955), *Impressionnistes de la Courtauld Collection*, no. 55.
London, Courtauld Institute (1958), *The Courtauld Collection*, no. 26.
London, Courtauld Institute (1976), *Samuel Courtauld's Collection of French 19th Century Paintings and Drawings*, no. 51.
Tokyo, Kyoto, and Osaka, Takashimaya (1984), *The Impressionists and the Post-Impressionists, Masterpieces from the Courtauld Collection, University of London*; Canberra, Australian National Gallery (1984), *The Great Impressionists, Masterpieces from the Courtauld Collection of Impressionist and Post-Impressionist Paintings and Drawings*, no. 85.
Cleveland, The Cleveland Museum of Art (January 14–March 8, 1987); New York, The Metropolitan Museum of Art (April 4–June 27, 1987); Fort Worth, The Kimbell Art Museum (July 11–September 27, 1987); Chicago, The Art Institute of Chicago (October 17–January 3, 1988); Kansas City, The Nelson-Atkins Museum of Art (January 30–April 3, 1988), *Impressionist and Post-Impressionist Masterpieces: The Courtauld Collection*, no. 37 (col. ill.).

Literature
Jamot, P., and P. Turner, *Collection de tableaux français faite à Londres par S. et E. Courtauld entre 1914 et 1931*, London, 1932, p. 29 (ill.), no. 49.
Cooper, D., *The Courtauld Collection*, London, 1954, no. 70, pl. 118.
Dorra, H., and J. Rewald, *Seurat—L'oeuvre peint, biographie et catalogue critique*, Paris, 1959, p. 261 (ill.), no. 201.
de Hauke, C., *Seurat et son oeuvre* I, Paris, 1961, pp. 180, 181 (ill.), no. 204.
Fry, R., and A. Blunt, *Seurat*, Greenwich, CT, 1965, pp. 84–85.
Chastel, A., and F. Minervino, *L'opera completa di Seurat*, Milan, 1972, pp. 109 (ill.), 110.
Simpson, I., "Seurat's Gravelines," *The Artist* 98, no. 7, July 1983, pp. 16 (ill.), 17.
Thomson, R., *Seurat*, Oxford, and Salem, NH, 1985, pp. 171, 183 (col. ill.).

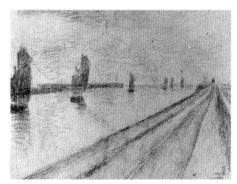

16

16

The Channel of Gravelines, 1890

Conté crayon on Michallet paper
9 ⁵/₁₆ x 12 ³/₁₆ inches (23.5 x 31 cm)
Private Collection, Paris

Provenance

Count Harry Kessler; Joseph Hessel; Georges
Rehns; Mme. Georges Rehns; Private
Collection, Paris.

Exhibitions

Paris, Galerie Paul Rosenberg (February 3–29,
1936), *Exposition Seurat*, no. 89 (with incor-
rect measurements).

Literature

de Hauke, C., *Seurat et son oeuvre* II, Paris,
1961, pp. 290, 291 (ill.), no. 699 [as *Petit Fort
Philippe*].
Russell, J., *Seurat*, New York, 1965, 1985 (rpt.),
pp. 250, 255 (ill.).
Chastel, A., and F. Minervino, *L'opera completa
di Seurat*, Milan, 1972, p. 110 (ill.).

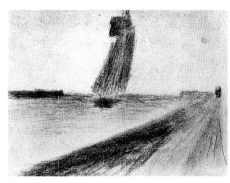

17

17

The Channel of Gravelines, 1890

Conté crayon on Michallet paper
9 ⁵/₁₆ x 12 ³/₁₆ inches (23.5 x 31 cm)
Private Collection
(Not in exhibition)

Provenance

Léon Appert (artist's brother-in-law), Paris; Mme.
Léon Roussel; Private Collection, Paris; Sale:
Paris, Ader Picard Tajan (November 18, 1989),
no. 7.

Literature

de Hauke, C., *Seurat et son oeuvre* II, Paris, 1961,
pp. 290, 291 (ill.), no. 700 [as *Petit Fort
Philippe*].
Herbert, R., *Seurat's Drawings*, New York, 1962,
pp. 154, 155 (ill.), 156, 186.
Chastel, A., and F. Minervino, *L'opera completa
di Seurat*, Milan, 1972, p. 110 (ill.).

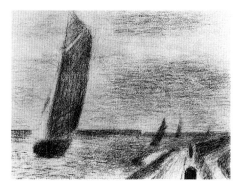

18

18

The Channel of Gravelines, 1890

Conté crayon on Michallet paper
8 ¹¹/₁₆ x 11 inches (22 x 28 cm)
Private Collection
(Not in exhibition)

Provenance

Count Harry Kessler; Joseph Hessel; Georges
Rehns; Private Collection.

Exhibitions

Paris, Galerie Paul Rosenberg (February 3–29,
1936), *Exposition Georges Seurat*, no. 90 (with
incorrect measurements).

Literature

de Hauke, C., *Seurat et son oeuvre* II, Paris,
1961, pp. 290, 291 (ill.), no. 701 [as *Petit Fort
Philippe*].
Chastel, A., and F. Minervino, *L'opera completa
di Seurat*, Milan, 1972, p. 110 (ill.).

Bibliography

Books

Blanc, Charles. *Grammaire des arts du dessin. Architecture, sculpture, peinture.* Paris, 1867.

Broude, Norma, ed. *Seurat in Perspective.* Englewood Cliffs, NJ, 1978.

Chastel, André, and Fiorella Minervino. *L'opera completa di Seurat.* Milan, 1972.

Cogniat, Raymond. *Seurat.* Paris, n.d. (ca. 1951).

Coquiot, Gustave. *Georges Seurat.* Paris, 1924.

Courthion, Pierre. *Georges Seurat.* New York, 1968.

Cousturier, Lucie. *Seurat.* Paris, 1921, 1926 (2d ed., enl.).

Dorra, Henri, and John Rewald. *Seurat–L'oeuvre peint, biographie et catalogue critique.* Paris, 1959.

Fénéon, Félix. *Oeuvres plus que complètes.* 2 vols. Ed. Joan U. Halperin. Geneva, 1970.

Fry, Roger, and Anthony Blunt. *Seurat.* London, 1965.

George, Waldemar. *Seurat et le Divisionnisme.* Paris, 1928.

Halperin, Joan Ungersma. *Félix Fénéon, Aesthete and Anarchist in Fin-de-Siècle Paris.* New Haven and London, 1988.

de Hauke, César M. *Seurat et son oeuvre.* 2 vols. Paris, 1961.

Herbert, Robert L. *Seurat's Drawings.* New York, 1962.

————. *Neo-Impressionism.* Exhibition catalogue, The Solomon R. Guggenheim Museum, New York, 1968.

Homer, William Innes. *Seurat and the Science of Painting.* Cambridge, MA, 1964, 1970 (2d ed.).

Kahn, Gustave. *Les Dessins de Georges Seurat.* 2 vols. Paris, 1928; New York, 1971 (new ed.).

Laprade, Jacques de. *Georges Seurat.* Monaco, 1945.

————. *Georges Seurat.* Paris, n.d. (ca. 1951).

Lee, Ellen W. *The Aura of Neo-Impressionism: The W. J. Holliday Collection.* Indianapolis Museum of Art, 1983.

Muller, Joseph. *Seurat–Dessins.* Paris, 1960.

Perruchot, Henri. *La Vie de Seurat.* Paris, 1966.

Rewald, John. *Georges Seurat.* New York, 1943, 1946 (2d ed., enl.), 1990 (3d ed., rev., enl.).

————. *Seurat.* Paris, 1949.

————. *Post-Impressionism: From van Gogh to Gauguin.* New York, 1956, 1962 (2d ed.), 1978 (3d ed., rev.).

Rich, Daniel C., ed., and Robert L. Herbert (essay on Seurat's drawings). *Seurat: Paintings and Drawings.* Exhibition catalogue, Art Institute of Chicago, 1958.

Roger-Marx, Claude. *Seurat.* Paris, 1931.

Russell, John. *Seurat.* New York, 1965, 1985 (rpt.).

Seligman, Germain. *The Drawings of Georges Seurat.* New York, 1947.

Signac, Paul. *D'Eugène Delacroix au Néo-Impressionnisme.* 1899. Ed. Françoise Cachin. Paris, 1964.

Sutter, Jean, ed. *The Neo-Impressionists.* Translated by C. Deliss. Neuchâtel, London, and Greenwich, CT, 1970.

Thomson, Richard. *Seurat.* Oxford, and Salem, NH, 1985.

Verhaeren, Emile. *Sensations.* Paris, 1927, pp. 195–203.

Articles

The Art Institute of Chicago. "Special Issue–The Grande Jatte at 100." *The Art Institute of Chicago Museum Studies* 14, no. 2 (1989).

Broude, Norma. "New Light on Seurat's Dot: Its Relation to Photo-Mechanical Color Printing in France in the 1880s." *The Art Bulletin* 56, no. 4 (December 1974), pp. 581–89.

————. "The Influence of Rembrandt Reproductions on Seurat's Drawing Style: A Methodological Note." *Gazette des Beaux-Arts* 58, pér. 6 (October 1976), pp. 155–60.

Cachin, Françoise. "Les Néo-Impressionnistes et le Japonisme, 1885-1893." In *Japonisme in Art,* an international symposium, Tokyo, 1980, pp. 225–37.

Christophe, Jules. "Seurat." *Les Hommes d'aujourd'hui* 8, no. 368 (1890).

Darragon, Eric. "Seurat, Honfleur et la 'Maria' en 1886." *Bulletin de la Société de l'Histoire de l'Art français* (1984), pp. 263–80.

————. "Pégase à Fernando, A propos de Cirque et du réalisme de Seurat en 1891." *Revue de l'Art* 4 (1989), pp. 44–57.

Dorra, Henri. "Charles Henry's 'Scientific' Aesthetic." *Gazette des Beaux-Arts* 74, pér. 6 (1969), pp. 345–56.

Dorra, Henri, and Sheila C. Askin. "Seurat's Japonisme." *Gazette des Beaux-Arts* 73, pér. 6 (February 1969), pp. 81–94.

Faunce, Sarah. "Seurat and 'the Soul of Things'." In *Belgian Art: 1880–1914.* Exhibition catalogue, The Brooklyn Museum, 1980, pp. 41–56.

Freeman, Dana. "Letters to and from the Editor." *Art History* 11, no. 2 (June 1988), pp. 150–54.

Gage, John. "The Technique of Seurat: A Reappraisal." *The Art Bulletin* 69, no. 3 (September 1987), pp. 448–54.

Goldwater, Robert J. "Some Aspects of the Development of Seurat's Style." *The Art Bulletin* 23, no. 2 (June 1941), pp. 117–30.

Hélion, Jean. "Seurat as a Predecessor." *The Burlington Magazine* 69, no. 400 (July 1936), pp. 4–14.

Herbert, Robert L. "Seurat in Chicago and New York." *The Burlington Magazine* 100, no. 662 (May 1958), pp. 146–55.

————. "Seurat and Jules Chéret." *The Art Bulletin* 40, no. 2 (June 1958), pp. 156–58.

————. "Seurat and Emile Verhaeren: Unpublished Letters." *Gazette des Beaux-Arts* 54, pér. 6 (July–December 1959), pp. 315–28.

Homer, William Innes. "Seurat's Port-en-Bessin." *The Minneapolis Institute of Arts Bulletin* 46, no. 2 (Summer 1957), pp. 17–41.

————. "Concerning Muybridge, Marey, and Seurat." *The Burlington Magazine* 104, no. 714 (September 1962), pp. 391–92.

House, John, and MaryAnne Stevens. "France." In *Post-Impressionism: Cross-Currents in European Painting.* Exhibition catalogue, Royal Academy of Arts, London, 1979, pp. 13–149.

Lee, Alan. "Seurat and Science." *Art History* 10, no. 2 (June 1987), pp. 203–26.

Natanson, Thadée. "Un primitif d'aujourd'hui: G. Seurat." *La Revue Blanche* (April 15, 1900), p. 164.

Prak, Niels L. "Seurat's Surface Pattern and Subject Matter." *The Art Bulletin* 53, no. 3 (September 1971), pp. 367–78.

Rey, Robert. "Seurat." In *La renaissance du sentiment classique dans la peinture française à la fin du XIXe siècle*. Paris, 1931, pp. 95–134.

Roger-Marx, Claude. "Georges Seurat." *Gazette des Beaux-Arts* 16, pér. 5 (December 1927), pp. 311–18.

Roslak, Robyn Sue. "Scientific Aesthetics and the Aestheticized Earth: The Parallel Vision of the Neo-Impressionist Landscape and Anarcho-Communist Social Theory." Ph.D. diss., University of California, Los Angeles, 1987, pp. 275–94.

Sakagami, Keiko. "L'Evolution de la Touche de Seurat à Travers Ses Marines." *Bulletin de la Société Franco-Japonaise d'Art et d'Archéologie* 5 (1985), pp. 18–31.

Schapiro, Meyer. "New Light on Seurat." *Art News* 57, no. 2 (April 1958), pp. 22–24, 44–45, 52.

Scharf, Aaron. "Painting, Photography, and the Image of Movement." *The Burlington Magazine* 104, no. 710 (May 1962), pp. 186–95.

Smith, Paul. "Seurat and the Port of Honfleur." *The Burlington Magazine* 126, no. 978 (September 1984), pp. 562–69.

Photo Credits